Washington Crossing the Delaware

RESTORING AN AMERICAN MASTERPIECE

Carrie Rebora Barratt, Lance Mayer, Gay Myers, Eli Wilner, Suzanne Smeaton

The Metropolitan Museum of Art, New York

Distributed by Yale University Press, New Haven and London

Contents

Reprint of *The Metropolitan Museum of Art Bulletin* (Fall 2011)

This publication is made possible through the generosity of the Lila Acheson Wallace Fund for The Metropolitan Museum of Art, established by the cofounder of *Reader's Digest*.

Additional support has been provided by The William Cullen Bryant Fellows of the American Wing.

Publisher and Editor in Chief: Mark Polizzotti
Associate Publisher and General Manager of Publications: Gwen Roginsky
Editor of the *Bulletin*: Sue Potter
Production Manager: Christopher Zichello
Designer: Bruce Campbell

Front, back, and inside covers: Details of Emanuel Leutze, *Washington Crossing the Delaware*, 1851 (see figs. 1 and 30)

Cataloging-in-Publication data is available from the Library of Congress
ISBN: 978-1-58839-439-2 (The Metropolitan Museum of Art)
ISBN: 978-0-300-17642-1 (Yale University Press)

Acknowledgments

The refurbishment of Emanuel Leutze's *Washington Crossing the Delaware* required the expertise and cooperation of many. Special thanks are due to the members of the curatorial and conservation staffs at The Metropolitan Museum of Art who consulted with the conservators and framers and shared ideas over the course of the four-year project, especially Morrison H. Heckscher, Elizabeth Mankin Kornhauser, Michael Gallagher, Charlotte Hale, Dorothy Mahon, Julie Arslanoglu, Kevin J. Avery, and Daniel Kurt Ackermann. We are grateful to the experts and technicians at the Museum who mastered an extraordinary installation, especially Luisa Ricardo Herrera, Cynthia Moyer, Sean Farrell, Dennis Kaiser, Chad Lemke, and Nikolai Jacobs. For the magnificent frame we are indebted to the studio and gallery staff at Eli Wilner & Company: Myron Moore, Felix Teran, Ernest Pollman, Xiomara Camacho, Myriam Patino, Boris Grozovsky, Jackie Hernandez, Vladimir Konikov, Raul Macas, Mary Hernandez, Carlos Mendieta, Marco Rengel, Juana Rosario, Carlos Villegas, Kevin Flaherty, Sean Morello, Jennifer Badran-Grycan, Emma Cotter, Ryan Roth, Cherie Werner, and Julie Simpkins; and, last but not least, to the unknown and unsung New York City frame makers who created the original frame for *Washington Crossing the Delaware* in 1851.

Director's Note

This issue of the Met's *Bulletin* represents a comprehensive study of Emanuel Leutze's *Washington Crossing the Delaware*, the grand painting that has pleased and fascinated Museum visitors for more than a century, since it entered the Metropolitan's collection in 1897. Over the past four years, the great canvas has been studied, conserved, and reframed, and its reinstallation heralds the opening of the final stage of a three-part renovation of the Museum's American Wing. The Wing's renewed painting and sculpture galleries will reopen to the public on January 16, 2012.

The monumentality, popularity, and historical significance of the painting make it the centerpiece of the comprehensive collections of the new American Wing. This *Bulletin* sheds light on the intensive effort that has re-created the original splendor and drama of Leutze's picture, which required extensive conservation treatment, and fitted it with a splendid new frame, a replica of the historic original the artist himself selected to aggrandize his major work. Readers will also gain a better sense of the history of *Washington Crossing the Delaware*, which Leutze painted in his studio in Düsseldorf, Germany, in 1851.

The painting's popularity—due to its scale, theme, and iconic subject matter—ensured that the image was emblazoned on the minds of mid-nineteenth-century Americans. Today, *Washington Crossing the Delaware* endures as a staple of the American art historical canon, and as one of the most recognizable images to the museum-going public. After the painting's initial display in October 1851 in New York City's Stuyvesant Institute, it graced a number of exhibition spaces, including the Rotunda of the U.S. Capitol, the grounds in New York's Union Square for the Metropolitan Fair in Aid of the United States Sanitary Commission near the close of the Civil War, and a private ballroom in New York, before the Met acquired it in 1897. Today, 115 years later, the Museum celebrates the reinstallation of *Washington Crossing the Delaware* as a prominent masterpiece in The American Wing.

The picture will hang in the company of some of the finest examples of American painting by the country's foremost painters: Frederic Edwin Church, John Singleton Copley, Gilbert Stuart, George Caleb Bingham, Winslow Homer, Thomas Eakins, and Mary Cassatt, to name only a few. More than 1,000 paintings, 600 sculptures, and 2,600 drawings will be displayed on the second floor of the New American Wing Galleries, constituting an encyclopedic survey of fine art in the United States from the late colonial period through the early twentieth century. For its size, historic impact, and aesthetic appeal, *Washington Crossing the Delaware* rightfully claims pride of place in the central space of the reconfigured galleries, where it can be viewed from a long vista as a welcoming beacon for the entire array of American art that will be on view.

The authors of this *Bulletin* are Carrie Rebora Barratt, formerly Curator of American Paintings and currently Associate Director for Collections and Administration; Lance Mayer and Gay Myers, the conservators responsible for the painting's extraordinary restoration; and Eli Wilner and Suzanne Smeaton, the framers who worked on an unprecedented scale to re-create its original frame. Their perspectives collectively illuminate the story of this canonical work in American art history and as one of the highlights of the Metropolitan Museum's collection.

We wish to express our appreciation to an anonymous foundation, which so generously supported the conservation of our American paintings, including the conservation and reframing of *Washington Crossing the Delaware*. We are grateful for the additional support received for this project from Mr. and Mrs. James F. Dicke II, Justine Simoni, Richard Hampton Jenrette, and Ronald Bourgeault. We extend thanks, as well, to the Peter Jay Sharp Foundation for the gift to name the gallery in which the painting now hangs. Finally, The William Cullen Bryant Fellows have our continued gratitude for their tremendous support of American art at the Met, and for their part in making this *Bulletin* possible.

Thomas P. Campbell
Director, The Metropolitan Museum of Art

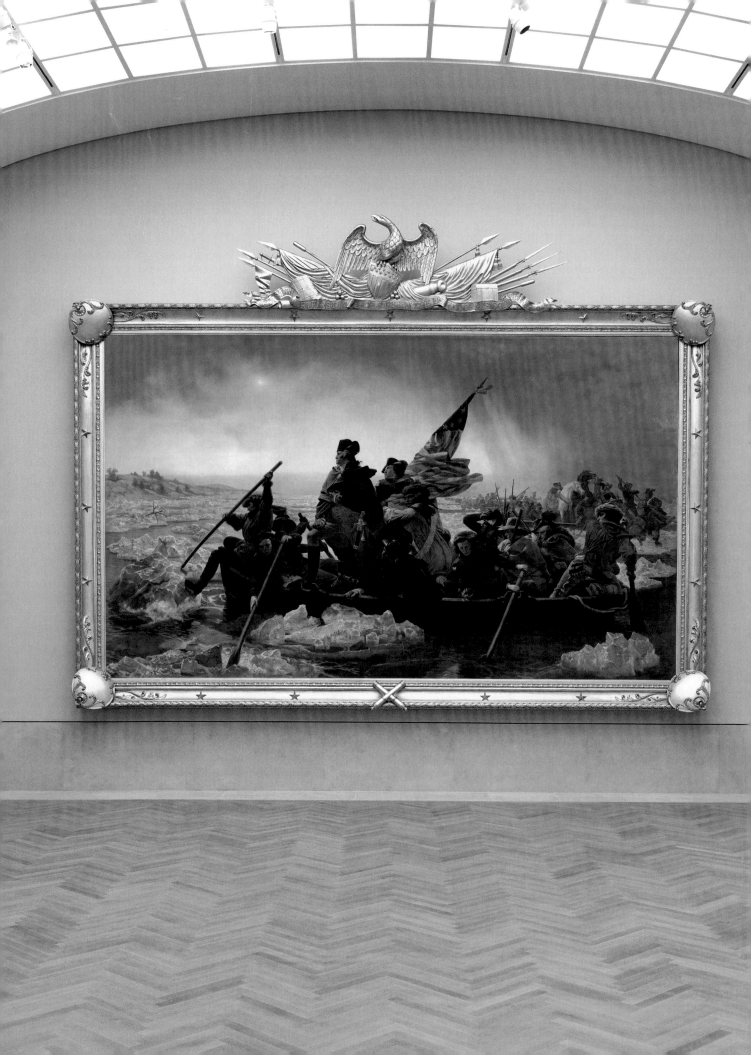

Washington Crossing the Delaware and the Metropolitan Museum

C A R R I E R E B O R A B A R R A T T

Emanuel Leutze first exhibited his masterpiece *Washington Crossing the Delaware* in New York City in the fall of 1851, just months after he had finished the painting in his studio in Düsseldorf. This winter, 160 years later, the picture has been newly reinstalled in The Metropolitan Museum of Art after more than four years of study, conservation treatment, and reframing aimed at capturing the artist's intentions for displaying and understanding his work (fig. 1). The grand high-ceilinged gallery in The American Wing was designed specifically for the painting so that it may be seen by many at once, in groups or as individual viewers, at a distance and up close, in a setting befitting not only its great size but also, and primarily, its panoramic composition and extraordinary detail. The Museum recognizes and welcomes the widespread and ongoing popularity of Leutze's painting, even as it respects the seriousness with which he conceived it in his Düsseldorf studio in the late 1840s.

Leutze (fig. 2) was born in Schwäbisch Gmünd, Württemberg, but he is considered an American artist because he spent his early life in Philadelphia, the city of choice for his refugee father. A draftsman and portraitist from his teenage years, he returned to Germany in 1841, when he was twenty-five, and enrolled in the Royal Art Academy in Düsseldorf. Even as a novice history painter Leutze showed a penchant for mannered theatrical renditions of subjects having to do with conquest. Early on, he received praise and awards for such pictures as *Columbus before the High Council of Salamanca* and *The Return of Columbus in Chains to Cadiz* (the location of the first unknown, the second in a private collection). After fairly exhausting the life of Christopher Columbus, Leutze next embarked on scenes from the Tudor dissolution and then, finally, moved from the old world to the new with a fixation first on the Mexican-American War and then backward in history to the American Revolution.[1] The thread connecting his subjects was revolutionary change, from what he saw as despotic rule in the old world to the land of the free that he experienced growing up in the United States and knew through the news as an adult. As Leutze scholar Barbara Groseclose has put it, *Washington Crossing the Delaware* "represents the summit of Leutze's projected cycle, the point at which his political and artistic evolution reached a maximum of intensity."[2] He conceived

1. Emanuel Leutze (American, born Germany, 1816–1868). *Washington Crossing the Delaware*, 1851. Oil on canvas, 12 ft. 5 in. x 21 ft. 3 in. (3.8 x 6.5 m). The Metropolitan Museum of Art, Gift of John Stewart Kennedy, 1897 (97.34). The painting, with its new frame, has been installed in the Peter Jay Sharp Foundation Gallery in the New American Wing Galleries for Painting, Sculpture, and Decorative Arts, which will open on January 16, 2012. See also fig. 30.

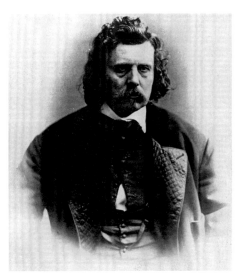

2. Emanuel Leutze, ca. 1840. Copy print of a photograph originally taken by John D. Shiff. Archives of American Art, Smithsonian Institution, Washington, D.C.

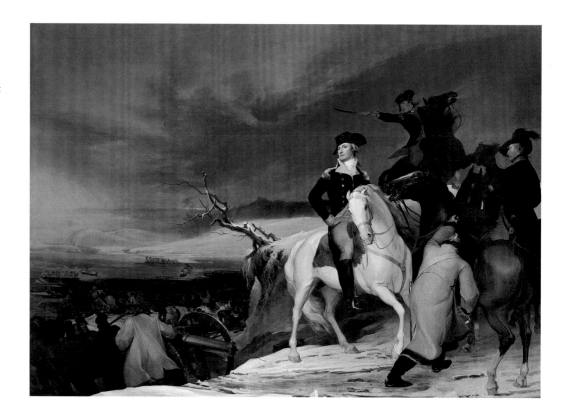

of the subject during the fractious Revolutions of 1848 in the German states. With the rise of the Prussian ruler Friedrich Wilhelm IV came governmental restrictions and the defeat of the revolutionaries, who held a common goal of unifying the nation but eventually failed because they could not agree on how that would be accomplished. Leutze took to his studio to compose an enormous homage to George Washington and the exemplary spirit that declared independence for the British colonies in North America. Groseclose suggests that Leutze may have taken his inspiration in part from the 1846 poem "Vor der Fahrt" (Before the Journey) by Ferdinand Freiligrath, in which a hopeful and determined crew in a ship named *Revolution* sets off in pursuit of freedom.

Leutze was the first artist to portray Washington in a boat and on such a grand scale. His project immediately caught the attention of Americans in Düsseldorf, and his studio mates and students—including American artists Worthington Whittredge, Eastman Johnson, and Albert Bierstadt—reported on his progress in their letters home.[3] Prior to Leutze, only one artist had rendered this particular historic event on canvas: in 1819 Thomas Sully painted the scene, with Washington on horseback directing the crossing from shore, on a 12-by-17-foot canvas (fig. 3) on commission for the state capitol of North Carolina (though in the end his picture was too large for the building). By October 1850 Leutze's scene was quite well along. According to Whittredge, Leutze pressed all of his tall American colleagues into service as models, "all the German models being either too small or too closely set in their limbs for his purpose." Whittredge posed for the steersman who sits in the boat's prow and also for Washington himself, wearing a perfect copy of the general's uniform borrowed from the U.S. Patent Office. "I was nearly dead when the operation was over," Whittredge complained. "They poured champagne down my throat and I lived through it."[4] Leutze based Washington's head on Jean-Antoine Houdon's bust of the president.

Given that he was painting a half century after the fact and a world away, Leutze did his best to create a historically accurate rendition of the event, Washington's crossing of the Delaware

River on Christmas night, 1776, just six months after the signing of the Declaration of Independence. At that point in the war the British forces had all but decimated the American troops, and Washington strategized what was to be the crucial move of the Revolution.[5] In order to mount a surprise attack against the encampment of Hessian troops supporting the British army at Trenton, New Jersey, Washington and his generals planned to cross the ice-covered river at seven places. Leutze depicted Washington making the crossing from McConkey's Ferry, Pennsylvania, to Johnson's Ferry, New Jersey, about ten miles north of Trenton, with a group of men that included Colonel James Monroe (holding the flag), General Nathanael Greene (leaning over the edge of the boat in the foreground), and Prince Whipple, Washington's black aide (working his oar from the far side of the boat). The others represent the loyal ranks of local fishermen and militiamen cast into service for the dangerous trek across the river.

Leutze lost his first canvas in a fire that swept through his studio on November 5, 1850, seriously damaging the painting. What was left of it was claimed by an insurance company, restored, and then in 1863 sold to the Kunsthalle in Bremen, where it was exhibited until it was destroyed during World War II (see fig. 24). Leutze lost no time starting on another, no doubt encouraged by Parisian dealer Adolphe Goupil's purchase of the yet unbegun picture. Not one to be discouraged, he instead took the opportunity to plot out a larger tableau and make improvements in the composition, the positioning of the men in the boats, the costumes, and the armaments. Eastman Johnson wrote to his friend Charlotte Child in March 1851 that after three months' work on the new picture Leutze was already about two-thirds finished, despite the commotion of his own making in the studio they shared. Leutze kept a cask of beer nearby and constructed a battery of flags, ammunition, and cannons in the room, "to give a more decided *tone* to the place."[6] With the picture nearly finished, he held a studio reception for the Prince

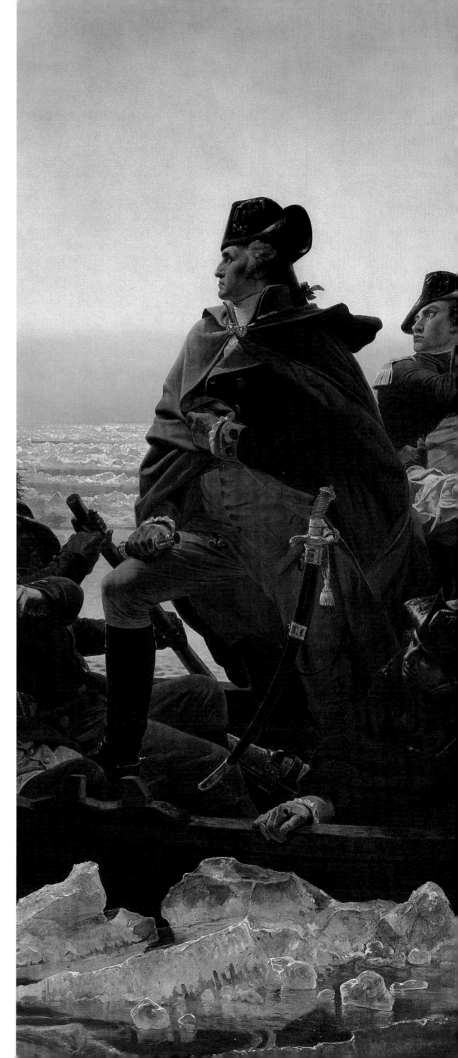

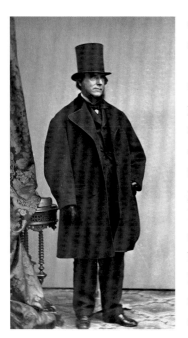

4. Studio of Mathew Brady, New York. *Marshall O. Roberts (1814–1880)*, ca. 1865. Glass negative print

and Princess of Prussia on May 11, 1851, but he continued to work on it into the summer, finally shipping it to New York for a fall exhibition at the Stuyvesant Institute.

The single-painting show opened to the public on October 29. On October 18, anticipating the opening, the *Literary World* deemed *Washington Crossing the Delaware* "incomparably the best painting yet executed of an American subject . . . , full of earnestness without exaggeration." A review in the November 1 issue of the New York weekly gazette the *Albion* praised the picture's execution and the painter's genius, remarking that "some who stand before it may be led to think of the hero's indomitable nerve, and some of the artist's able hand—but we defy any one possessed of one grain of sensibility to look upon it, unmoved." And on November 7 the *New York Evening Mirror* proclaimed it "the grandest, most majestic, and most effective painting ever exhibited in America." Among the crowds who filed past the painting were Henry James, then a boy of only eight or nine, and his parents. Many years later James recalled the impact it had on him: "I live again in the thrill of that evening. . . . We gaped responsive to every item, lost in the marvel of the wintry light, of the sharpness of the ice-blocks, of the sickness of the sick soldier, of the protrusion of the minor objects, that of the strands of the rope and the nails of the boots, that, I say, on the part of everything, of its determined purpose of standing out; but that, above all, of the profiled national hero's purpose, as might be said, of standing *up*, as much as possible, even indeed of doing it almost on one leg, in such difficulties, and successfully balancing."[7]

At the time Leutze conceived the picture, images and tales of George Washington were ubiquitous in America. On the fiftieth anniversary of his death, the first president had become a nearly mythological figure, and Leutze's topical, nostalgic picture was a sensation akin to a modern-day blockbuster. More than 50,000 people saw the painting before the exhibition closed on February 28, 1852. Still more saw it on exhibition in the Rotunda of the United States Capitol between March 15 and April 4. Within the year the picture was fixed in the American imagination, as chromolithographs, prints, and needlework pictures popularized the image. Mark Twain would later remark that every grand home along the Mississippi River between Saint Louis and Baton Rouge had over its mantel an engraving of *Washington Crossing the Delaware* or "on the wall by the door, [a] copy of it done in thunder-and-lightning crewels by one of the young ladies—[a] work of art which would have made Washington hesitate about crossing, if he could have foreseen what advantage was going to be taken of it."[8]

While the painting was on view in Washington, a contingent of congressmen offered to purchase it for the White House, but Leutze revealed that he had already sold it to the New York collector Marshall O. Roberts (fig. 4), presumably through the agency of Goupil. Roberts reportedly paid $10,000 for *Washington Crossing the Delaware* in 1851. A capitalist who made his wealth during the 1840s by taking over a government contract subsidizing mail steamships, Roberts secured his fortune by selling boats to the federal government during the Civil War. He eventually amassed a collection of 172 contemporary paintings by American and European painters, including Frederic Edwin Church, John F. Kensett, William Sidney Mount, Richard Caton Woodville, Richard Wilson, and Constant Troyon.[9]

Roberts moved *Washington Crossing the Delaware* from his home only once during his lifetime, in April 1864, when he lent it to the Art Exhibition at the Metropolitan Fair in Aid of the United States Sanitary Commission held in New York's Union Square. President Abraham Lincoln had created the Sanitary Commission in 1861 to coordinate volunteer efforts, principally by women, for hospitals, kitchens, and visiting nurse services during the Civil War. Art

exhibitions and fundraisers were held in many major cities during the war. The New York fair, held near the war's end, was organized under the leadership of Mrs. Jonathan Sturges, wife of one of the city's great art collectors. The contemporary landscape painter John F. Kensett chaired the artists committee—on which Leutze served—and the trustees committee was comprised of Roberts and two other capitalist art collectors, New York merchants Abraham M. Cozzens and William T. Blodgett (a founder of The Metropolitan Museum of Art and chairman of its first executive committee). Hung floor to ceiling in one long gallery were 360 paintings, primarily by local living artists and lent by local collectors. Listed first in the catalogue, with two pages of historical description, was *Washington Crossing the Delaware.* Leutze's painting held the end wall of the gallery of the display (fig. 5), flanked by Frederic Church's *The Heart of the Andes* of 1859 and Albert Bierstadt's *The Rocky Mountains, Lander's Peak* of 1863 (both of which are now also in the Metropolitan). Savvy visitors would have recognized that the three pictures represented the contem-

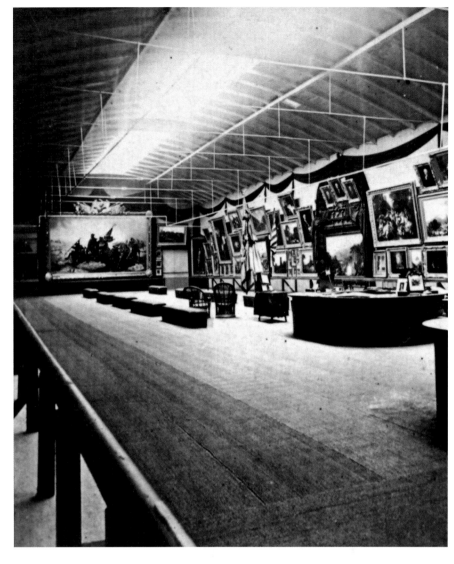

5. Picture gallery at the Metropolitan Fair in Aid of the United States Sanitary Commission, New York, 1864. One-half of a stereograph

porary expansionist vision of America: Leutze's reminded viewers of the historical actions that formed the United States, Bierstadt's celebrated the exploration of the American West, and Church's lauded ventures in South America.

By 1864, however, critical opinion had done an about-turn, and Leutze's picture came under attack as theatrical and contrived. The harshest commentary came from the *New-York Times,* whose critic carped that Washington possessed "the head and air of a dancing-master, [who stood] upon the prow of the boat ready to teeter ashore and dance a pirouet on the snow."[10] According to Mark Thistlewaite, an expert on images of Washington, Leutze's masterpiece "offers a prime example of the widening split between highbrow and lowbrow culture" as New Yorkers became more sophisticated in matters of culture and art.[11]

Washington Crossing the Delaware gained back some of its credence over the next forty years as it languished in virtual hiding in the picture gallery of Roberts's New York home, two adjoining town houses on Fifth Avenue. Roberts used his picture gallery as a ballroom. The society pages of the *New-York Times* on January 30, 1887, reported that at the dinner dance Roberts's widow had hosted the Thursday before, "the first art gallery, with its broad marble stairways and delightful nooks and corners and its famous pictures of a quarter of a century ago—notably Leutze's 'Washington Crossing the Delaware'—was at all times the favored

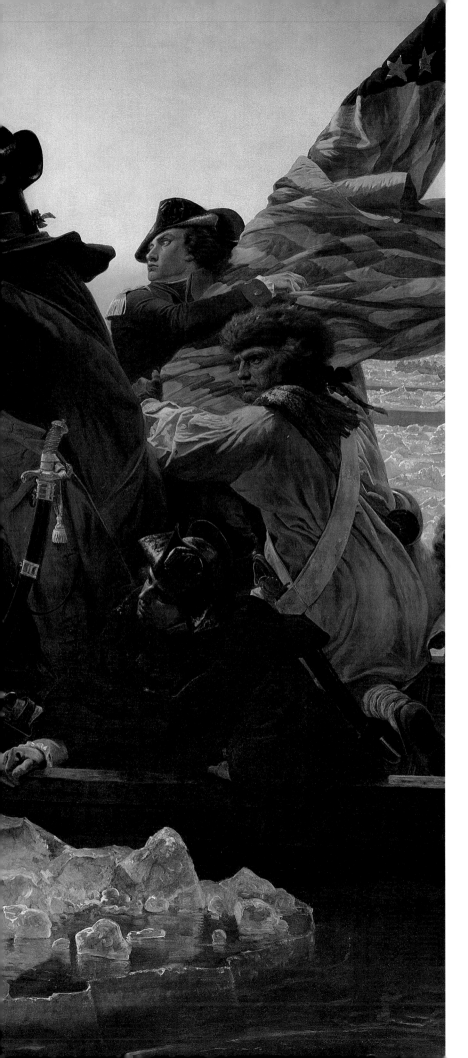

resort, and every palm and fern had a sofa under it occupied by a couple."

Roberts seems to have bought pictures only rarely after the Civil War. His collection was a time capsule of contemporary art from mid-century, and more than one critic called it old-fashioned. After Roberts died in 1880 his family waited seventeen years before they dispersed his paintings, and when his collection came up for auction at Chickering Hall in New York over two nights in late January 1897, estimates were low. One critic called the auction "a farce in the matter of returns" due to the current unpopularity of mid-century academic and landscape paintings.[12] Remarkably, the Leutze saved the sale. The first night grossed $8,764, the second $32,990, nearly half of which came from the purchase of Leutze's painting by dealer Samuel P. Avery Jr. on behalf of John S. Kennedy. According to the report of the sale the *New York Times* published on January 21, "the contest was spirited and exciting," with Avery bidding against two other interested parties, a Mr. Kauffmann and an agent representing the Corcoran Gallery of Art in Washington. The auctioneer, Mr. Somerville, opened the bidding at $5,000, and it rose in thousand-dollar increments to $15,500. The Corcoran agent bid $16,000, and Avery cast the winning bid, $16,100. "A burst of applause followed the final drop of the hammer," the *Times* continued, "and this grew into a shout when Mr. Somerville announced that Mr. Kennedy would present the painting to the Metropolitan Museum of Art."

Scottish-born financier John Stewart Kennedy (fig. 6) made most of his fortune negotiating loans and performing banking services for the railroad business, principally channeling European capital into the railroads being built in the western states. He became a junior partner in the Glasgow firm of M. K. Jessup and Co. in 1856 and thereafter spent a good deal of his time in the United States. In 1868 he opened

his own merchant banking firm, J. S. Kennedy and Co., in New York, and by the time he dissolved the company in 1883 he was deeply affiliated with the city's financial community. Kennedy accumulated an estate worth about $60 million, most of which he bequeathed to New York City's cultural institutions. He was a generous, if inconspicuous, donor of funds to the New York Public Library and the Presbyterian Hospital and of works of art and funds to the Metropolitan Museum.

Before bidding on *Washington Crossing the Delaware*, Kennedy had asked the president of the Metropolitan's Board of Trustees, Henry G. Marquand, and its curator of paintings, George Henry Story, whether they would accept the picture as a gift should he succeed in getting it. They concurred that the painting would be "a desirable acquisition."[13] Too big to be moved to the auction room, the picture was sent directly from Roberts's home to the Museum and was on view within four months, by late April 1897, when Museum Director Luigi Palma di Cesnola invited Kennedy to a private viewing and reception.[14] The canvas covered the entire end wall of the gallery of American pictures in the Morgan Wing (see figs. 7–9), a display not unlike the exhibition at the Metropolitan Fair, where the monumentality and subject matter of the work compelled prominence. Although it quickly became a crowd-pleaser especially appealing to children, families, and school groups, viewers and Museum officials alike were still hard-pressed to take the canvas seriously as a work of fine art.

As the Museum's paintings collection grew, so did the need to move the great picture. It remained in place for thirty years, until 1929, when the bequest of the H. O. Havemeyer collection inspired a total rehanging of the picture galleries. Moving *Washington Crossing the Delaware* presented not only logistical but also programmatic issues. Deinstalling the gigantic picture would not be easy, and taking it down

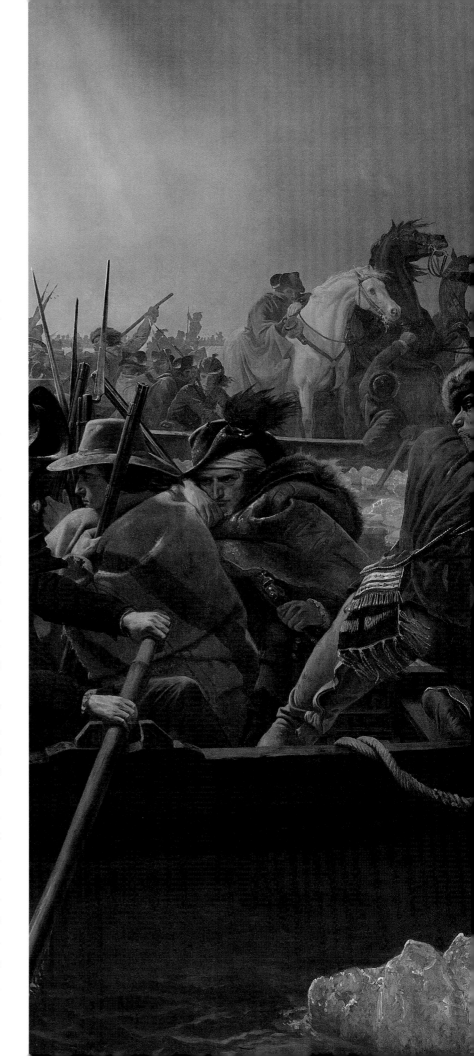

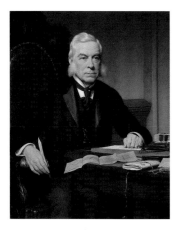

6. Seymour Joseph Guy (American, born England 1824–1910). *John S. Kennedy (1830–1909)*, 1903. Oil on canvas. 42 ½ x 34 ½ in. (108 x 87.6 cm). New York State Museum, Albany, New York Chamber of Commerce, The Partnership for New York City, Inc. (H-2003.41.64)

was bound to elicit criticism from the schools, the trustees of the Museum, and the heirs of John S. Kennedy. Curator of Paintings Bryson Burroughs favored taking it down and suggested that the Museum arrange "a semi-permanent loan of this picture to the New York City School Board."[15] Even as the painting was being removed from view and stored, Museum Trustee and President Robert W. de Forest, who in 1924 had founded The American Wing, took up the gauntlet in opposing Burroughs's idea, offering alternative solutions in a series of memorandums to H. W. Kent, the Museum's secretary and counsel. De Forest asked that then Museum director Edward Robinson and his staff look for any possible place to hang the picture, including "halls and corridors," before taking the rash measure of removing it from the premises, rather sarcastically proposing a stretch of wall in "the attic between Miss Gash's office and the fan."[16] The Museum's Eighty-third Street entrance, near the Lecture Hall, where children entered the building, was considered, but the ceilings were a foot short. While other options were floated, Burroughs entertained loan requests from a wide range of outside institutions, including the Pratt Institute, the Roxy Theatre, the 107th Armory, the Chesapeake & Ohio Railway Company, West Point Military Academy (for the cadets' mess hall), the city of Fresno, California, and the New York State Educational Building in Albany.[17]

The picture apparently remained in storage for nearly three years as letters flew back and forth. Finally, in 1932, Museum President William Sloane Coffin mandated that it be hung at the entrance to the new American Wing to commemorate the bicentennial of Washington's birth. On January 12 Coffin released a statement to the press explaining that except for the great masterpieces, it is impossible to show "all of the paintings all of the time," so the curators routinely change the hang (a message that is even more true now than it was then, when the collection was far smaller). *"Washington Crossing the Delaware,"* he continued, "cannot be classified as a masterpiece, nor is it an accurate historical record. Nevertheless, we believe that it is both fitting and desirable that this picture should be shown at the time of the Washington Bicentennial, . . . because in spite of obvious defects it has great interest for many people

7. Metropolitan Museum visitors admiring *Washington Crossing the Delaware*, 1907

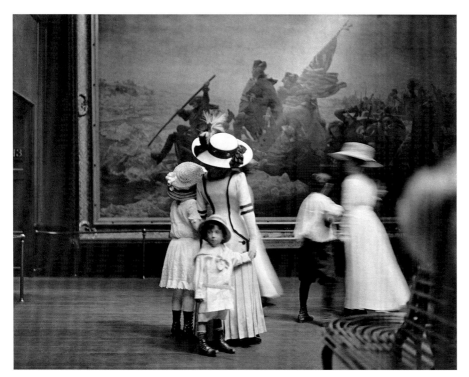

in this country." Robert E. Tod, John S. Kennedy's nephew and the executor of his estate, worried that its return to view was only temporary, offered in a letter to Coffin to "make arrangements to have the picture transferred to the Museum of the City of New York or the Brooklyn Museum, either of which would be glad to secure it and to exhibit it steadily."[18] Coffin quickly replied that the Museum had found "an excellent place" for the painting in The American Wing and pledged that if ever in the future it had to be taken off view the Museum would make it available to another institution for display.[19]

Between January and September 1932 nearly 125,000 people (one in every six visitors to the Museum) saw *Washington Cross-*

ing the Delaware. Museum Director Herbert Winlock found the statistic persuasive but nonetheless asked the board to consider lending the painting to another worthy institution.[20] Burroughs continued to campaign for its removal "both because of its size and because of its lack of importance in the history of American Art." Joseph Breck, head of the Department of Decorative Arts, which at the time included The American Wing, wished to devote the space to displaying the early American decorative arts that were the Wing's raison d'être. They both recommended lending the painting to West Point, the New York State Educational Building, or the Pratt Institute.

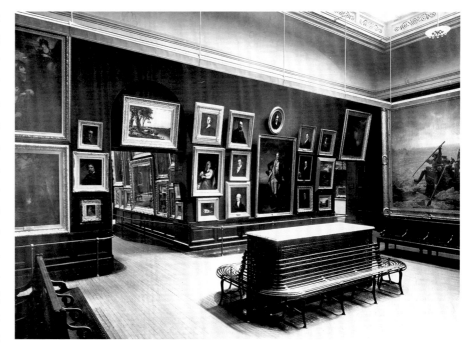

8. *Washington Crossing the Delaware* on display in the Morgan Wing of The Metropolitan Museum of Art, 1907

Nonetheless, the painting's sheer size and popularity obviated any quick decisions about removing it, and it remained on view in The American Wing and then in the Museum's main hall until the spring of 1946. Even then, the curators appear to have decided to deinstall the painting without consulting Museum Director Francis Henry Taylor. It had already been taken down, removed from its stretchers, and rolled by the time Taylor heard conservator Murray Pease's "anguished protest." Pease feared that rolling the painting would be highly detrimental to the unlined canvas, which would now have to be lined before it could ever be restretched again.[21] In November 1946 Taylor scolded his staff for taking such an action without his authority and directed them to see that the picture was back on view by Washington's Birthday,

9. *Washington Crossing the Delaware* on display in the Morgan Wing, 1918

February 22, 1947. It was to be given precedence in the conservation studio "over any work in the laboratory at the present moment or contemplated." For the first time in the Museum's history, visitor response was allowed to override curatorial opinion in determining whether to keep a painting on view: "I am not concerned with what the Department thinks of the painting aesthetically," Taylor explained. "I am, however, deeply concerned with public reaction to a painting which has become through the years a symbol of American life. It is one of the important historical documents of which the Museum has possession and custody. The very fact that it has attracted so much attention in the press is ample evidence of

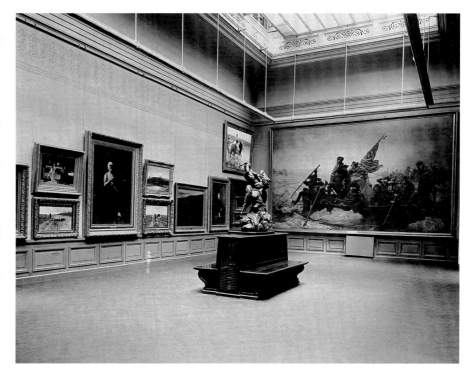

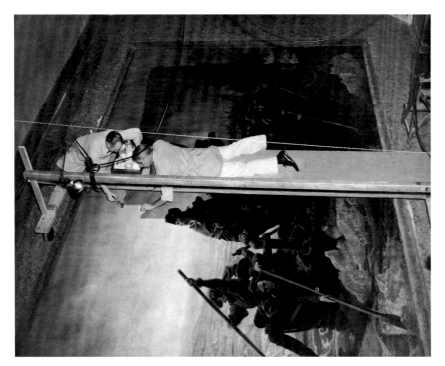

10. Conservation treatment of *Washington Crossing the Delaware*, 1947. Working from "the George Washington Bridge," Murray Pease, curator of the Technical Laboratory at the Metropolitan Museum, and his assistant Patrick Staunton removed accumulated grime and discolored varnish.

11. Lining *Washington Crossing the Delaware*, 1947. In the relining process the painting was stretched, facedown, over the smooth platform, and over it was stretched the heavy reinforcing linen. Under a battery of infrared heat lamps the adhesive (a mixture of beeswax and resin) was manipulated with a thermostatically controlled relining iron.

the very genuine fondness of many thousands of Americans for this picture."[22]

The subsequent charette to get the picture up in time involved considerable effort: the picture had to be cleaned (see fig. 10), 280 square feet of imported unseamed Irish linen to line the back of the canvas had to be ordered and a space cleared for a 22 x 13 foot lining platform (see fig. 11), a new demountable stretcher had to be designed and built, adequate wall anchors had to be installed in the gallery, and it all had to be timed so that the freshly lined and varnished painting had time to dry before it went on public display. Pease's plan for the project, outlined in numerous detailed memorandums to all the participants, was tight and risky. On January 21, a month before the deadline, he was forced to send back the new stretchers he had so carefully drawn to specification because the butt-end joints were failing even before they were installed. In typical Metropolitan Museum fashion, however, all obstacles were surmounted. By February 20 Pease could announce that "Operation Delaware" had been successfully completed, on schedule, and that all concerned had worked with "efficient and enthusiastic cooperation."[23]

The Museum kept the painting on view for the next three years, until Pease undertook "Operation Delaware 2" or "the Second Crossing of the Delaware," as he called it: a loan to the Dallas Museum of Fine Arts, who planned to display it during the Dallas State Fair in fall 1950. Throughout the summer Jerry Bywaters, director of the Dallas museum, corresponded frequently with Pease about the "weighty piece of business" upon them, namely, "the problem of getting George Washington across the Hudson and then the Delaware, and finally across the Trinity river."[24] Insured for $50,000—just over three times its purchase price a half century earlier—the painting was deinstalled, unstretched, rolled on a drum, packed, trucked, and then unrolled, restretched, and hung in

Dallas (see fig. 12). Pease documented the trip and the procedure in great detail, making extensive lists of supplies, tools, and staff requirements.

Dallas reported that more than 100,000 visitors saw the painting in two weeks during late October, compelling Bywaters to request that the painting remain with them "semi-indefinitely, at least until after Christmas." In a holiday spirit that recognized the inevitable, given that there would be no place for it back home for a number of years, Mrs. H. D. Allen, the Metropolitan's loans officer, replied that he could keep the picture in Dallas as long as he wanted it.

News of the Dallas loan found its way to the organization for which Washington's heroic crossing held greatest importance: the Washington Crossing Park Commission of the Commonwealth of Pennsylvania. The commissioners requested that the Metropolitan's board extend the loan of the picture to the park, which they considered a much more congenial and apt location than Dallas, and the Metropolitan's executive committee approved a two-year loan, to commence on Washington's Birthday in 1952. The terms were renewable, but the plan was to recall the picture to New York at the end of the initial loan period. Perhaps inevitably, however, considering that unstretching, dismantling, and packing it in Dallas took three days and installing it in Pennsylvania even longer, the painting would remain at Washington Crossing well beyond the anticipated two years.

Over the years the Metropolitan had developed a generous program of lending works of art to other institutions through a process involving insurance documents, facilities checks, and shipping arrangements that continues to this day. The documentation of the loan of *Washington Crossing the Delaware* to Dallas is extensive. Yet the transfer of the picture from Dallas to Pennsylvania could be written simply as a series of unfortunate events. Even as the staff in Dallas was dutifully dismantling and rolling the painting for transport by train, letters from

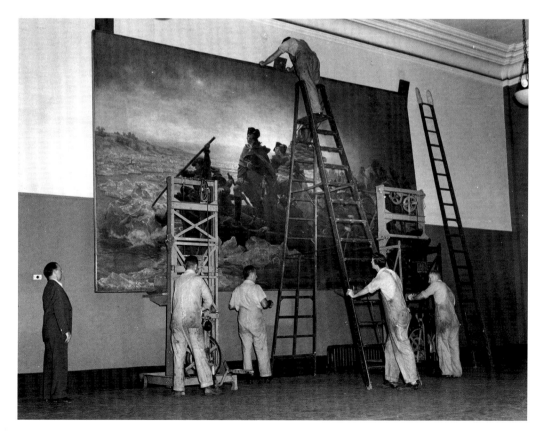

12. Deinstalling *Washington Crossing the Delaware* at the Metropolitan Museum for its loan to the Dallas Museum of Fine Arts, September 14, 1950

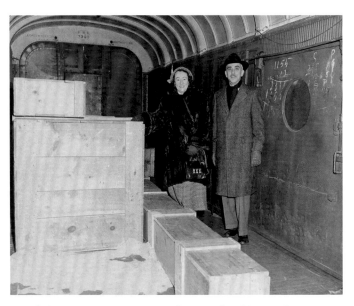

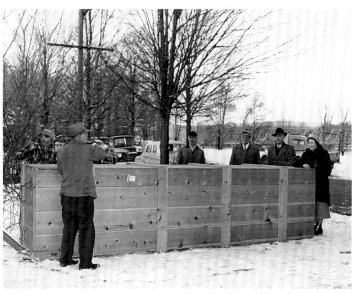

13. Park Commissioner Ann Hutton and Metropolitan Museum Conservator Murray Pease meeting the train carrying *Washington Crossing the Delaware* in Trenton, New Jersey, February 1952

14. *Washington Crossing the Delaware* in its crate outside the United Methodist Church, Washington Crossing, Pennsylvania, February 1952

those on the receiving end revealed a rather makeshift operation, and notes preserved in the Museum's archives express the staff's concern about the sketchy plans. J. L. Allen, associate curator of paintings, asked, "Do we know where they mean to hang it?" The Reverend Jesse G. Eaton, pastor of the United Methodist Church at Washington Crossing, wrote to Murray Pease on January 22, 1952, informing him that the church would be the painting's temporary home until a proper exhibition gallery could be built. He enclosed a sketch of the wall on which the picture would be mounted.[25] In addition to Reverend Eaton, who looked forward to having the painting on view for his congregation, the person in authority at Washington Crossing was Park Commissioner Ann Hawkes Hutton, who ordered draperies to adorn the painting at the church.

Pease outlined the detailed nine-step procedure for installing the painting in the church, with or without draperies. On a snowy day not unlike the day Washington and his troops crossed the Delaware, he met the painting at the railroad station in Trenton and saw it into the truck and to the church (see figs. 13–16). The *New York Herald Tribune* reported on February 18, 1952, that the installation required the removal of the church doors, the removal of half the pews, and two days of stretching the 800-pound canvas on butcher paper spread on the floor before park workmen could raise it into place.[26] Mrs. Hutton proclaimed that the painting was "coming home" and announced that her goal was to keep the painting at Washington Crossing permanently.

On November 4, 1953, Mrs. Hutton, who had risen to the position of chairman for public relations at the park commission, wrote to Dudley T. Easby Jr., the Metropolitan's secretary and counsel, to ask for an extension of the loan, arguing that the "rightness" of the picture's display at Washington Crossing was demonstrated by the quarter-million viewers who had been to see the picture during the previous eighteen months.[27] The Metropolitan agreed to extend the loan first for one year and then for another three. The park commissioners had yet to build a proper gallery for the painting, but Mrs. Hutton explained that they would do so only if the Metropolitan would give or sell the picture to them. Museum Director James J. Rorimer turned to Theodore Rousseau Jr. for his recommendation. The curator's answer, in 1955, signaled a change in the Metropolitan's approach to the big painting: "It has fallen from grace in the opinion of modern

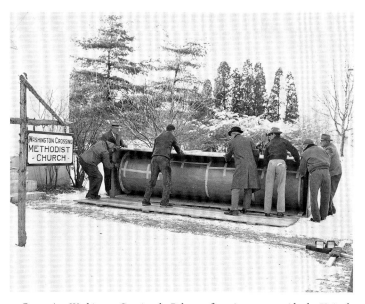

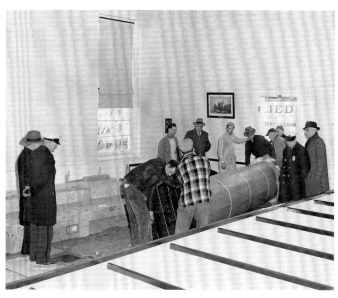

15. Removing *Washington Crossing the Delaware* from its crate outside the United Methodist Church, Washington Crossing, Pennsylvania, February 1952

16. *Washington Crossing the Delaware* rolled on its drum arriving at the United Methodist Church, Washington Crossing, Pennsylvania, February 1952

art critics, but this does not mean that it will not appeal to people again sometime in the future, nor does it eliminate its historical interest."[28]

Once they learned that the Museum would not be giving them the painting, the Washington Crossing Park commissioners mounted a campaign to keep it for as long as possible and finally broke ground for the new building. Pease supervised the move of the painting from the church to the new gallery building in August 1959. On his return to New York he briefed Rorimer that Mrs. Hutton was talking to her fellow commissioners, the press, and members of the public about the commission's intention to keep the painting in perpetuity. He was "more than ever convinced that [Mrs. Hutton] is capable of blowing up quite a storm" should the Metropolitan stand firm on its decision to retain ownership.[29] Indeed, the picture had by then been a fixture at the Bucks County site for so long that few recalled that it was owned by the Metropolitan. In his remarks celebrating the opening of the Washington Crossing State Park Memorial Building in 1959, Pennsylvania Governor David L. Lawrence failed to mention the Metropolitan at all, even though he stood in front of the painting that was its centerpiece. In the end, Rorimer agreed to lend *Washington Crossing the Delaware* to the park for five more years, but he increased its insurance value to $200,000.

In October 1966, when planning was under way for the construction of a new American Wing, the Museum sent curators Claus Virch and Margaretta Salinger to Washington Crossing to see Leutze's painting and determine whether it should be brought back to New York. They admired the "shrine" that housed the picture and remarked that its presence there was the only reason for the Memorial Building, which had recently been named a national monument by the U.S. Department of the Interior.[30] In March 1968 Assistant Curator John K. Howat published an article about the painting in *The Metropolitan Museum of Art Bulletin* that compelled the Museum's new director, Thomas Hoving, to request a history of the loan to Washington Crossing.[31] A populist at heart who was reconfiguring the Metropolitan's exhibition program to attract a broader audience, Hoving wanted *Washington Crossing the Delaware* back in his museum. He offered Ann Hutton and her fellow commissioners permission to make a full-scale copy of the

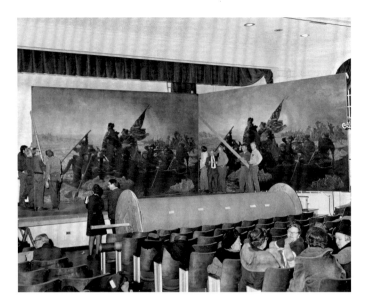
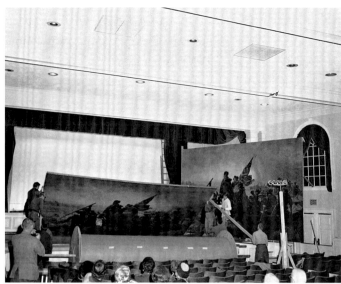
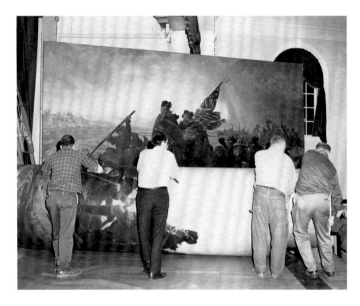
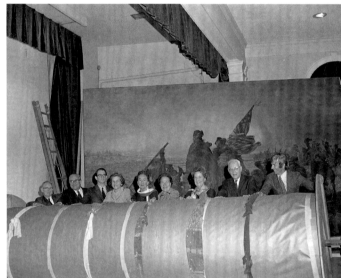

17–20. *Washington Crossing the Delaware* being removed from the wall in the Washington Crossing State Park Memorial Building and rolled on to a drum in preparation for its return to the Metropolitan Museum, January 1970. To the right of the original is the copy painted for the Washington Crossing Park Commission by Robert B. Williams. Williams is at the far right in fig. 20 (lower right), and John K. Howat, the Metropolitan's assistant curator, is third from left, surrounded by the park commissioners.

picture for their museum in anticipation of the original's recall to New York. There followed a series of deceptively polite letters between Hoving and Hutton. She implied that the Metropolitan was reneging on its obligation to the country's schoolchildren, scouts, and patriots. He brought in lawyers, including the Museum's new secretary, Ashton Hawkins. The exchange culminated with Hutton agreeing to commission a copy of the painting from a notable contemporary artist. When Hoving requested that the original be returned to the Metropolitan in time for the special exhibition "19th Century America," scheduled to open on April 16, 1970, Hutton asked that the original be returned to Pennsylvania after the exhibition closed in September. "To avoid some particularly unpleasant publicity in the patriot press," Hoving made sure that Howat could find a place to display the picture once the exhibition was over.[32]

Braving the nationalist uprising of petitioners and protesting schoolchildren in Pennsylvania, Howat traveled to Washington Crossing in October 1969 to assess the copy and make plans for the deinstallation of the original in January 1970. He worked with Chief Conservator Hubert von Sonnenburg on the task at hand, which followed Pease's notes from thirty years prior almost to a tee, except that this time the enterprise involved not only dismantling and rolling the original

but also installing the copy in its place (figs. 17–19). Press photographs of the day (fig. 20) suggest an air of collegiality and acceptance, but Hutton was continuing to request the return of the picture after the exhibition. The campaign was obviously a labor of love for her. She had dedicated her life to the story of Washington crossing the Delaware, and she wished to tour the copy of Leutze's great painting across America, to hundreds of venues, once the original was firmly back in her museum. To close the matter, on November 24, 1970, Douglas Dillon, chairman of the Metropolitan's board, advised Mrs. Hutton to be grateful for the loan of so many years past. "The situation has changed," he informed her, "and the painting is no longer available for loan."[33]

After the celebrated return of the picture to the Metropolitan for the landmark exhibition "19th Century America," *Washington Crossing the Delaware*—too large to store or to hang—was moved from place to place in anticipation of its final place of honor in the new American Wing, which opened in 1980. The picture held a long wall for many years (fig. 21) and was never moved an inch, so loath were modern conservators to roll the canvas again in light of the picture's travel history. While figures do not exist for how many have seen the picture over the years, the number must run into the hundreds of thousands. The gallery was continuously filled with visitors, especially schoolchildren, standing or sitting on the floor listening to teachers or curators talk about the historic event itself and about Leutze's intentions to tell the tale of heroic liberty on a monumental scale.

Washington Crossing the Delaware remained on the same wall until February 2009, when it was the last canvas removed before renovation of the American Wing galleries (fig. 22). The painting is now back on view, in a frame that reconstructs its original presentation in 1851 and flanked once again by *The Heart of the Andes* and *The Rocky Mountains, Lander's Peak* in a subtle reconfiguration of its showing at the Metropolitan Fair in 1864. It has found its true place of honor at the Metropolitan as a work of historic and aesthetic importance beloved by the public and meaningful to Americans and international visitors alike, indeed to anyone who values freedom.

21. *Washington Crossing the Delaware* on the wall in The American Wing where it hung from 1980 to 2009

22. Deinstalling *Washington Crossing the Delaware* in The American Wing, 2009. Leutze's painting was the last to be removed from the galleries in preparation for the renovation.

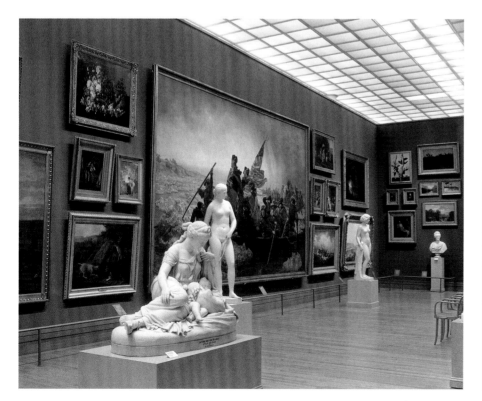

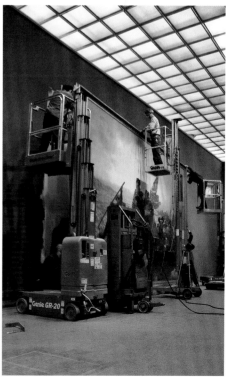

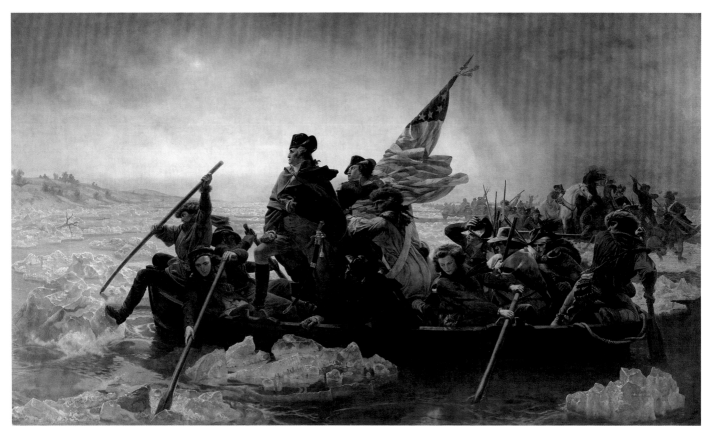

23. *Washington Crossing the Delaware*, before conservation treatment

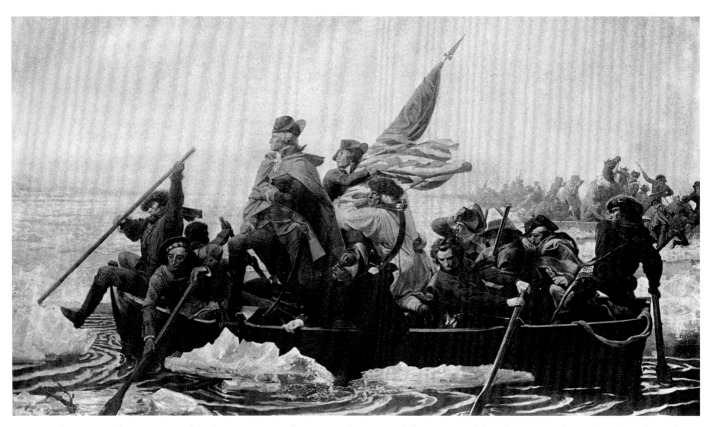

24. Emanuel Leutze. *Washington Crossing the Delaware*, 1849–50. Oil on canvas. This is Leutze's first painting of the subject. It was damaged in a fire in his studio in November 1850, but by December he had repaired it sufficiently for it to be exhibited first in Cologne and then in Düsseldorf and Berlin. The Kunsthalle Bremen acquired the canvas in 1863, and it hung there until it was destroyed in a bombing raid in September 1942.

Emanuel Leutze's *Washington Crossing the Delaware* through Conservators' Eyes

Lance Mayer and Gay Myers

S tanding in front of Emanuel Leutze's enormous *Washington Crossing the Delaware* and studying it objectively, as conservators must do before contemplating a conservation treatment, is a daunting prospect. It is difficult to disentangle the painting, as a physical object, from the iconic image so familiar to all Americans. One of the most important tasks of a conservator is to understand the relationship between the physical and the intangible aspects of a work of art: we must ask ourselves, for instance, whether the alteration of specific materials over time has changed the aesthetic, emotional, or even the symbolic meaning that a painting has for a museum visitor. We must also decide whether there are any concrete actions that we can take to mitigate conditions that might interfere with the viewer's experience.

We first examined *Washington Crossing the Delaware* in the spring of 2007 (see fig. 23), and treated it over the course of the following two years. The painting was generally in very good condition, considering that, like many large paintings, it had been rolled and unrolled to carry it through doorways and to transport it over the years. The painting was acquired by the Metropolitan Museum in 1897 and remained on view until 1946 without any recorded conservation treatment. In 1946 the painting was taken off view and rolled on a cylinder over the "anguished protest" of Museum conservator Murray Pease, who worried that the canvas had become too weak. In 1947 Pease cleaned the painting, lined it by adhering an additional fabric to the reverse with wax-resin adhesive, and stretched it on a new, sturdier stretcher (see figs. 10, 11). In 1950 the lined painting was rolled, unrolled, and restretched when it traveled to Dallas for the Dallas State Fair, and the process was repeated in 1952 when it was sent from Dallas to the Washington Crossing State Park in Pennsylvania, where it remained until 1970 (see figs. 12–16). In 1970 the painting was again rolled for shipment (see figs. 17–19) and was restretched when it arrived back in New York. The painting was once more rolled, unrolled, and restretched during the final phases of construction of The American Wing in 1980.

Plans for the renovation of The American Wing included rehanging *Washington Crossing the Delaware* in a prominent position at the end of a long vista—an additional incentive to make it look its best. The fabrication of a new, elaborate frame based on an early photograph would also bring renewed attention to the painting, and the closing of the galleries during renovation provided the opportunity to conserve the painting while it was off public view.

In the years since its last cleaning in 1947, the surface coating of the painting had darkened and become matte and hazy, and some areas of old retouching had become noticeably dark. Curator Carrie Rebora Barratt pointed out a more subtle but perplexing problem: it was difficult to discern the morning star (the planet Venus), which Leutze depicted in the upper left part of

the sky. The star plays an important role in the composition, both in setting the time of the event during the hours just before dawn and as a symbol of the dawn of hope during the darkest days of the American Revolution. The goal of revealing the morning star—and hence part of the symbolic meaning of the painting—would become an important part of the conservation treatment.

Studying the canvas intensely, at very close quarters, also revealed new things about the making of the painting in Düsseldorf in 1851. Leutze's first large version of the composition, formerly in the Kunsthalle Bremen, was destroyed during World War II and now exists only in a photograph (fig. 24). The Bremen painting was begun late in 1849. When it was nearly complete, in November of 1850, it was damaged in a studio fire. The painting, by this time owned by an insurance company, was sufficiently restored by December 1850 to be exhibited in Cologne, and it was also shown in Düsseldorf and Berlin before the Bremen museum acquired it in 1863. Leutze began a new version, the one now in the Metropolitan Museum, in January 1851, and he had it ready to ship to New York by the summer.[34] Comparison of the Metropolitan Museum painting with the photograph of the Bremen painting shows that although the two versions are nearly identical in most respects, Leutze took the opportunity to change his composition in subtle but significant ways.

Many of these changes make the scene more dramatic. For instance, in the Bremen painting the pole wielded by the man in the bow is perfectly straight, but in the Metropolitan Museum version it has a slight bend, which emphasizes the great force with which the man is pushing against the ice floe in front of the boat. Leutze also changed the position of the ice floes, separating the floes next to the side of the boat to make a large, dark green gap in the water that dramatically sets off the diagonal line of the oar pulled by the frowning man in the red jacket and makes the viewer feel the energy of his stroke. This oarsman's hands have also been changed. In the Bremen painting his hands are quite close together, but in the Metropolitan version they have been moved farther apart, which not only renders his grip on the oar more forceful but also makes for a more pleasing arrangement of lights and darks in this part of the painting. (It has been pointed out, however, that the present position of the

right hand is incorrect because it would give the rower poor leverage against the fulcrum of the oarlock.) This change necessitated a last-minute change to the right-hand part of the oarlock, which had to be moved farther to the right to keep the oarsman from bumping his knuckles against it.

In his second version Leutze de-emphasized the gap between the ice floes in front of the bow of the boat, making them seem even more difficult to pass through. In the Bremen painting he represented the movement of the water around each ice floe with a series of light-colored concentric rings or ripples. He may have realized that these lines looked somewhat stylized and unconvincing, for in the Metropolitan Museum version he almost completely eliminated them. Instead, white water splashes forcefully against the largest ice floe directly in front of the bow, as if in reaction to the energetic action of the man who is kicking it with his boot as he simultaneously pushes against an adjacent chunk of ice with his pole. A large ice floe in the lower right corner of the painting occupies a space that in the Bremen composition had been somewhat empty, relieved only by concentric ripples.

25. Infrared reflectogram of a detail of *Washington Crossing the Delaware*, showing changes Leutze made to the outline of Washington's hat, the size of his hair ribbon, and the profile of his face

Other differences between the versions include the wind-whipped middle portion of the flag, which in the New York picture was given a more complex and voluminous series of folds. The top of the flagpole in the New York painting has windblown tassels that were lacking in the Bremen version. The lowest part of the flag that extends out to the right was also shortened slightly, and the outlines of Washington's hat and the hat of the man directly behind him were changed. The men and horses on the right side of the middle distance were redeployed, and bayonets were added that make sharp vertical and diagonal lines across this group. Leutze redrew the stern of the boat, a nearly straight vertical line in the Bremen painting, to give it a curved outline that makes the perspective more convincing. The lengthening of the stern meant that the rightmost figure, the man in the green shirt, had to be rethought: the top portion of his body remains the same, but his legs and hips were shifted, resulting in the somewhat odd anatomy of his buttocks. The side of the boat nearest the viewer also rides deeper in the water in the second version, so the boat seems more precariously overloaded.

A few of Leutze's initial drawing lines, which were applied to the off-white ground before any paint was applied, are visible to the naked eye in the Metropolitan's painting. Traces of underdrawing in red can be seen, for instance, in the area around Washington's bent leg. Leutze seems to have favored red-colored underdrawings, to judge by a small, unfinished study for the scene in which the underdrawing was done entirely in red.[35] A few black underdrawing lines are also visible, between the legs, for instance, and to the left of the man holding a pole near the right edge.

To better understand the underdrawings and what they might tell us about the genesis of the painting and its relationship to the earlier Bremen version, Metropolitan Museum conservator Charlotte Hale examined the painting with us using infrared reflectography. While many areas of the painting show no underdrawing lines at all when viewed with the infrared camera, underdrawing can be seen in several places.[36] Among the changes that are visible as discrepancies between the underdrawing and the final paint layers are the outline of Washington's hat, the size of his hair ribbon, and the profile of his face (fig. 25). The outline of the middle section of the

26. Infrared reflectogram of a detail of *Washington Crossing the Delaware*, showing changes Leutze made in the outline of the right side of the middle section of the flag

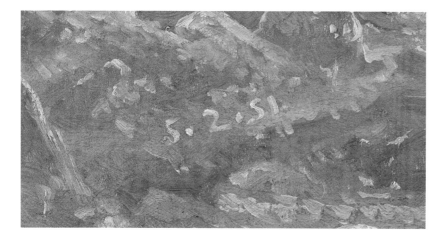

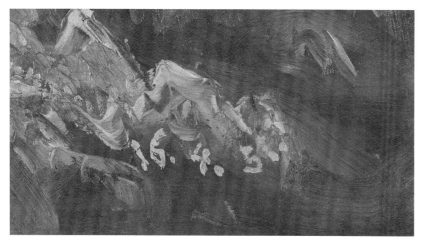

27–28. Details of *Washington Crossing the Delaware*, showing *5. 2. 51* painted in the water just above the roots of the fallen tree caught in the ice near the left edge of the painting and *16. 4. 51* painted just to the right of where the largest oar meets the water in the lower left corner

flag was originally drawn to extend farther out to the right, as in Leutze's first version of the scene (fig. 26). Slight alterations were also made to the outline of the left hand of the pole man with the fur cap. In the face of the man with the tam-o'-shanter and in his left hand there are lines of underdrawing that seem to relate to the two figures behind him, as if they were sketched in rather completely before the figure in front of them was drawn.

Pentimenti, or changes the artist made while he was painting, can be seen in the hats of Washington and the man immediately to his right, as well as in the flag. Leutze appears to have first painted these areas following the lines of his underdrawing, then rethought the outlines and repainted them. The right half of the oarlock of the oarsman in a red shirt was moved farther to the right; the increased transparency of the paint over time permits a ghostly image of the previous oarlock to show through. The reins of the rearing brown horse in the middle distance were also rearranged, perhaps because the horse's head was lowered, one of the many differences between this group of men and horses in the Bremen painting and the later version.

Two somewhat puzzling sequences of numbers were painted into the light-colored highlights of the ice floes, as if they were not intended to be easily seen. Immediately above the roots of the fallen tree caught in the ice near the left edge someone painted *5. 2. 51*, and *16. 4. 51* appears at the lower left just to the right of where the largest oar meets the water (figs. 27, 28). The numbers appear to represent dates—February 5, 1851, and April 16, 1851—both plausibly during the time Leutze was working on the painting. Letters from Eastman Johnson, who was sharing Leutze's atelier at the time, document that the composition was two-thirds finished in March 1851 and that a reception was held in May to celebrate its completion.[37] This kind of semi-concealed dating is very unusual in nineteenth-

century painting (or indeed in painting of any period). Leutze himself may have been documenting different stages of the work, or perhaps the dates were painted by a bored or mischievous assistant wanting a bit of immortality and hoping that Leutze would not notice. Leutze did employ assistants for his large paintings, and Worthington Whittredge and Andreas Achenbach can be documented as having worked on the sky of the first version of *Washington Crossing the Delaware*. Since Eastman Johnson was working in Leutze's studio at the time, he must be considered a suspect.[38]

The most challenging aspect of the treatment was to understand the appearance of the painting in all its complexity and to decide what could or should be addressed. The original color scheme of the painting was certainly somewhat low in tone, with all of the colors having a unity of tone tending toward brown.[39] This has probably been accentuated to some degree by the aging of the artist's medium. There is a pervasive pattern of fine wrinkling in the paint layers, which hints that the artist used an excess of oil or some other medium in his paint. In a few places the paint appears to have aged somewhat unevenly; some strokes of paint are browner than the adjacent strokes, as if at different times the artist applied paint containing a greater quantity of medium or a different medium, which now has a slightly different color. It was customary in the nineteenth century for painters to dip their brush into a cup of medium attached to their palette, which resulted in differing amounts of medium being applied in different areas.

The sky, in particular, had an unevenly dark and patchy appearance, and the morning star was difficult to discern because it was surrounded by swirling, accidental patterns of dark and light unrelated to the artist's painting of the sky. Some of the unevenness may be attributable to the uneven darkening of materials in the artist's paint, but a significant amount of it was probably a result of the cleaning of the painting in 1947. Tests showed the presence of residues that had the characteristics of grime, varnish, and wax, as if all three materials had become intermixed during the previous conservation treatment. A photograph taken during the 1947 cleaning (fig. 10) shows that the

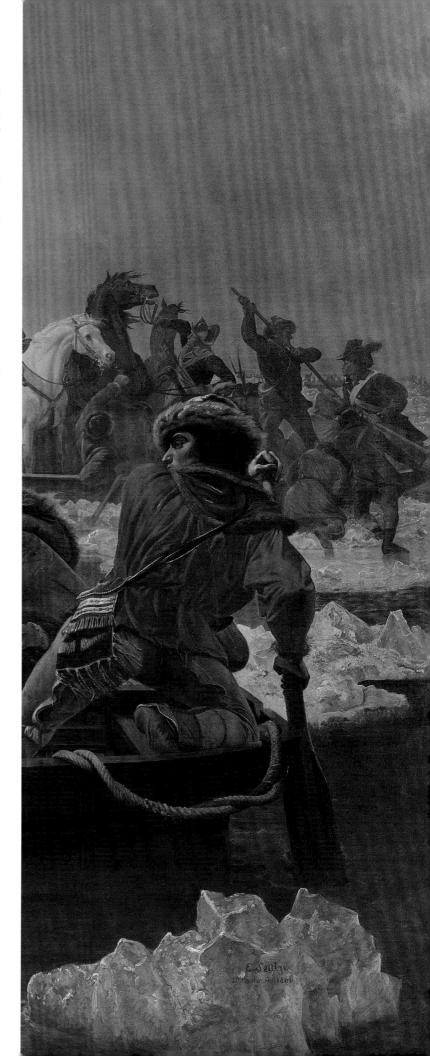

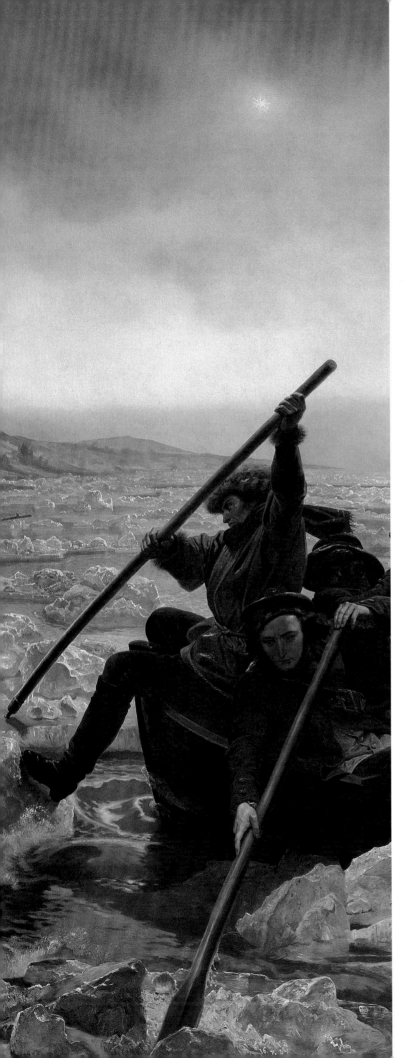

layer that was removed was extremely dark, and it appears that grime was removed together with the discolored surface coating, which could have led to their becoming intermixed. It is also possible that a strong solvent or reagent used in the 1947 cleaning may have swelled the paint and caused grime and other residues to bond firmly to the surface. In some places the paint appeared darker where the surface was most wrinkled, because deposits adhered more stubbornly in the hollows of the paint texture. Some additional grime had accumulated since the 1947 treatment as well.

Perhaps the most noticeable way in which the painting had changed over time was that the surface was very matte and hazy. This was especially disfiguring in the darkest parts of the boat and the figures in the foreground, which were so undersaturated that one could not see the full range of values, and this in turn tended to flatten out the space. It would have been normal for the painting to have been revarnished after it was cleaned and lined in 1947. But surprisingly, instead of a conventional varnish coating we found a layer that had the characteristics of wax or a wax-containing mixture.[40] Notes made at the time the painting was treated in 1947 mention plans to apply a varnish and express concern that it would be difficult to illuminate such a large picture without reflections if the coating was too glossy, but they do not say which type of coating was actually applied. Although it would have been unusual, that a wax-based coating might have been chosen makes sense, because there had been a surge of interest in matte varnishes based on wax during the 1920s, 1930s, and 1940s, especially for mural paintings where a low gloss was preferred.[41]

The cleaning of the painting was far from simple because of the intermixed and interlayered accumulations of wax, grime, and, in a few areas, patches of aged varnish left behind after the 1947 treatment. An additional complication was the presence of wax adhesive that had oozed through cracks from the back to the front when the painting was lined. Because the accumulations varied from area to area, we did not clean all parts of the painting to the same degree. Since some areas already appeared too clean, we focused our attention on the darkest deposits, applying our solutions with small cotton swabs that allowed us to carefully control the degree of cleaning.[42]

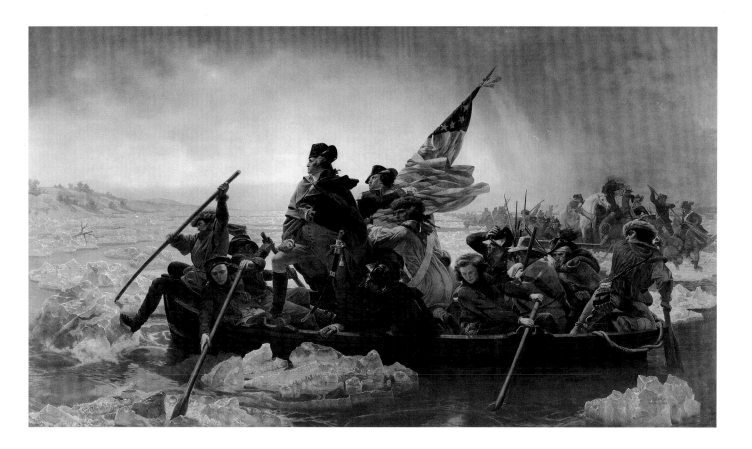

Once we had removed all of the darkened materials we could (without making additional spots that were too clean), we varnished the painting with a thin layer of synthetic resin that mimics the kinds of natural resin varnishes, such as mastic and dammar, that would have been used in Leutze's time (see fig. 29). We inpainted the areas of paint loss, as well as the old, insoluble retouching, with paints that will not discolor and will remain easily removable if the treatment needs to be repeated in the future. Much of the old retouching was done in oil paint, which had become insoluble and was therefore allowed to remain. It was important, however, to correct the worst of the darkened retouching, which appeared along the line of men and horses in the middle distance in the right-hand part of the painting, in order to make the recession of space work properly in this area of the composition.

Many small strokes of inpainting needed to be applied in the sky, employing both glazing (applying very thin layers of transparent, dark paint where the sky appeared too light) and scumbling (applying tiny spots of light paint to places where dark, insoluble deposits remained in the hollows of the paint texture). During inpainting, we repeatedly rolled the scaffolding away and walked back fifteen paces or more to see what the effect would be from a distance. This was crucial to making the morning star gradually emerge and appear distinctly against the sky.

Conservation treatment has produced a change that is subtle and difficult to capture in photographs but that is quite noticeable when one is actually standing in front of the painting (see fig. 30). The new varnish saturates the darker colors and allows one to see the full range of values from dark to light. Leutze's composition is like a stage performance, with most of the action taking place in the foreground. But for the drama to work, the space must function properly. The viewer must feel that the ice floes extend almost limitlessly into the distance, showing how difficult Washington's crossing will be. The sky is also an important part of the drama:

29. *Washington Crossing the Delaware* after cleaning and before inpainting, 2009

dawn is breaking and the weather is chang-
ing, as shown by the diagonal beams of sun-
light striking through the clouds to the right
of the flag. These effects are symbolic, and
the conservation treatment makes the viewer
feel them more strongly.

We felt the multilayered meanings of
this painting keenly while we were working
on it on the day of President Obama's inau-
guration. We had shifted the scaffolding so
that both the first president and the African
American man rowing next to him could
share—symbolically—the inaugural address
shown on our computer screen nearby. Our
jaws dropped simultaneously when Presi-
dent Obama began describing patriots "on
the shores of an icy river" in "the year of
America's birth, in the coldest of months,"
continuing to the exhortation: "Let us brave
once more the icy currents." The majority of
listeners at that moment were probably visu-
alizing Leutze's powerful depiction of the
scene, a symbol of hope and courage in the
face of adversity. Even though many visitors
to the Museum are already familiar with the
image, we trust that conservation treatment
will enhance their experience when they see
the painting in the reinstalled American Wing.

30. Emanuel Leutze (American, born Germany, 1816–1868).
Washington Crossing the Delaware, 1851, after conservation
treatment. Oil on canvas, 12 ft. 5 in. x 21 ft. 3 in. (3.8 x 6.5 m).
The Metropolitan Museum of Art, Gift of John Stewart
Kennedy, 1897 (97.34)

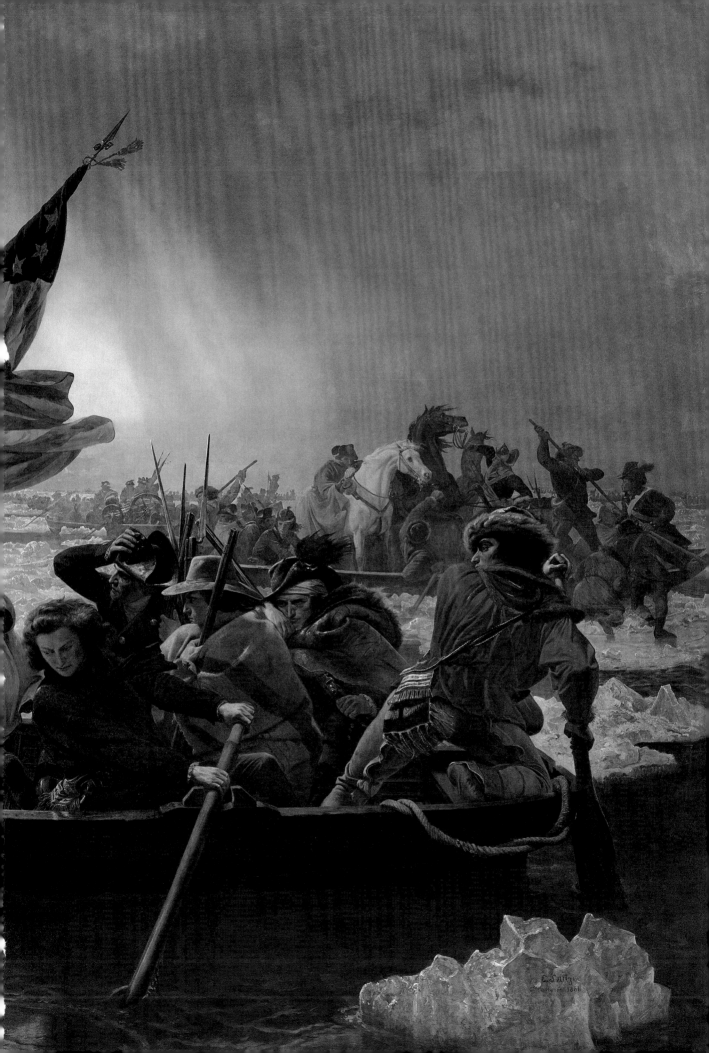

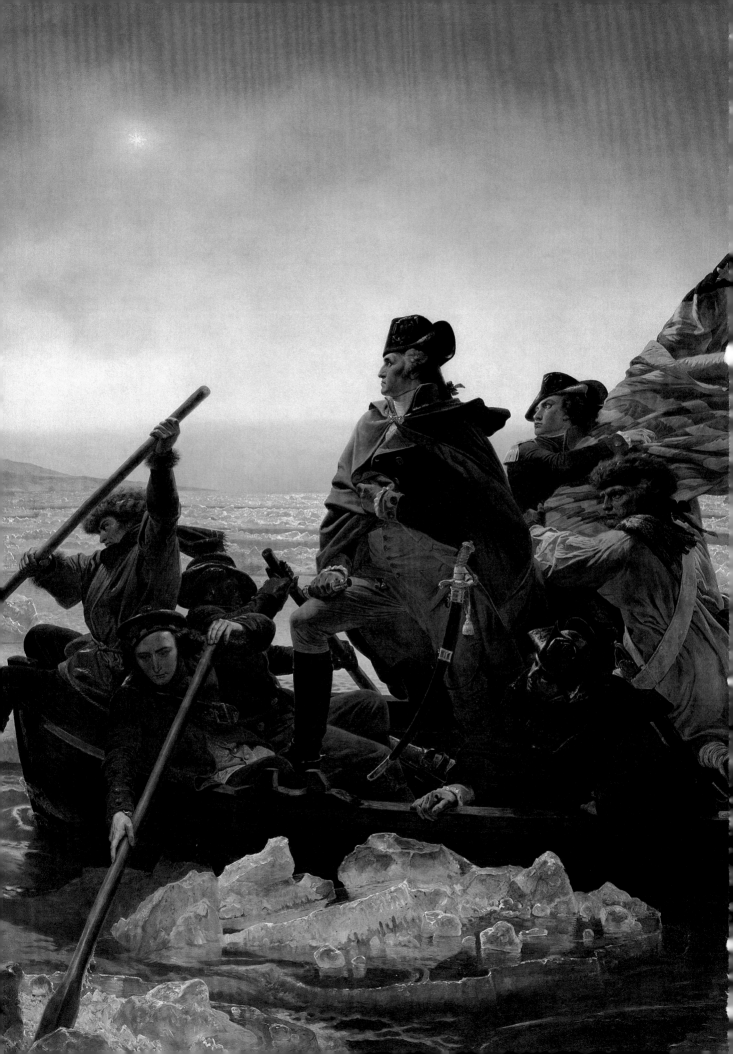

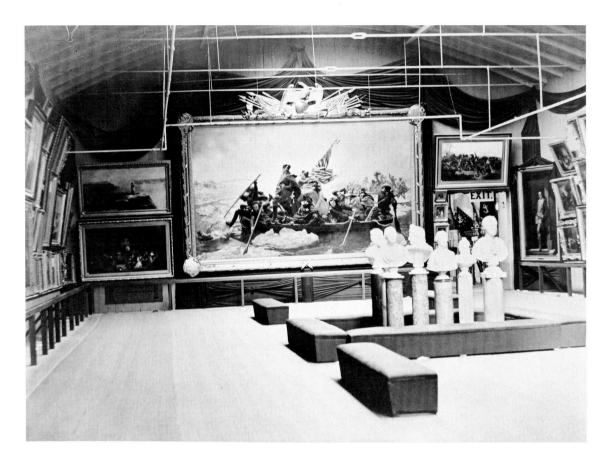

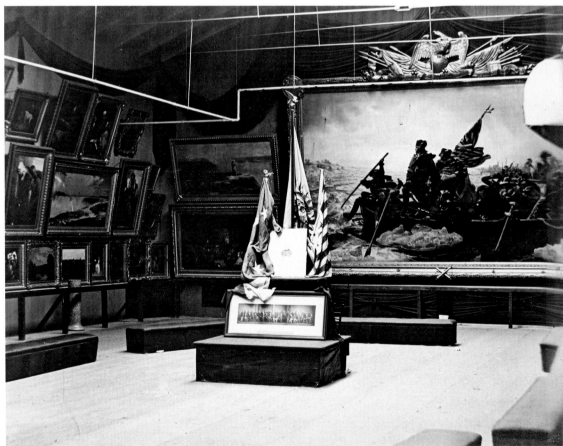

31–32. Studio of Mathew Brady, New York. Photographs from the album *Recollections of the Art Exhibition at the Metropolitan Fair New York 1864*, showing *Washington Crossing the Delaware* hanging at the end of the long exhibition hall. New-York Historical Society (78828d, 78829d)

Setting a Jewel: Re-creating the Original Frame for *Washington Crossing the Delaware*

ELI WILNER AND SUZANNE SMEATON

odern-day museum curators and collectors alike give great thought and care to the proper display of works of art, seeking to honor the original intent of the artist and his time. Research in the field provides considerable information about specific periods and styles of frames. A particular pattern of ornament, a precise type of leaf, or a specific tonality of gilding contributes to the understanding of what comprises a historically appropriate frame. If available, period photographs that illustrate works in their original frames are an invaluable resource. Over the past two decades many paintings in The American Wing of the Metropolitan, among them *Madame X* by John Singer Sargent, *The Champion Single Sculls (Max Schmitt in a Single Scull)* by Thomas Eakins, and *Lydia Crocheting in the Garden at Marly* by Mary Cassatt, have received more historically appropriate and aesthetically complementary frames.

One painting in particular, however, provoked passionate concern: *Washington Crossing the Delaware* by Emanuel Leutze. While many are familiar with the iconic depiction of Washington's valiant crossing, few realize that the painting is enormous: 12 feet tall and 21 feet across. And yet at least since 1918 it had been enclosed in a plain, narrow, gilded frame unbecoming a canvas of such monumental size and import. Although art historians suspected that the iconic painting must once have been given a frame more in keeping with its size and subject, years of research had yielded little information. That changed in 2006. Kevin J. Avery, then a curator at the Metropolitan, was searching for information at the New-York Historical Society about another painting when he came upon a leather-bound volume that the famed nineteenth-century photographer Mathew Brady had titled *Recollections of the Art Exhibition at the Metropolitan Fair New York 1864*.[43]

Considered the father of photojournalism, Brady (1823–1896) studied with daguerreotypist Samuel F. B. Morse before striking out on his own in 1844. During the Civil War he photographed a number of Union and Confederate officers and organized a staff of more than twenty assistants who went directly to the battlefields to capture the harsh realities of war. Today the thousands of images Brady produced serve as the most important visual documentation of the Civil War. He also made photographs of eighteen American presidents, including several well-known portraits of Abraham Lincoln.

Brady was a member of the art committee for the Metropolitan Fair in 1864, and he exhibited some of his photographs and then donated them to the benefit auction. Held on behalf of the nonprofit United States Sanitary Commission, the fair sought to raise money for supplies and aid for injured Union soldiers. Like a small World's Fair, it showcased Yankee industry and ingenuity. Brady's studio's photographs of the art gallery at the fair (figs. 31, 32) show Leutze's magnificent painting displayed in an equally dramatic frame replete with patriotic regalia, including

a crest several feet across crowned by a spread-winged eagle. Fortuitously, the thrilling discovery of the photographs coincided with plans for the renovation and expansion of The American Wing and the reinstallation of its paintings galleries. It was an opportune moment to reconsider how Leutze's painting should be displayed, and the Museum called on Eli Wilner & Company to re-create the magnificent eagle-crested frame.

We set about the daunting task of turning just two small photographs into a much larger three-dimensional object. Moving from a two-dimensional reference to a three-dimensional object poses obvious challenges. The 1864 photographs were indistinct or out of focus in places. There was no view from the side that would have allowed us to discern the relief of the crest and other ornamental objects. The best photograph was taken at a slight angle to the frame, so we had to account for foreshortening and consider how the view of the crest—fifteen feet above the bottom of the frame—was affected. The enormous size of the frame posed a problem. We estimated that it would weigh 2,000 pounds, so we needed to determine how to join it safely and how to mount the crest.

Our task began in 2007 with extensive research provided by the curatorial staff at the Metropolitan.[44] A fascinating, comprehensive report confirmed our belief that the frame had been made when the painting was first exhibited in 1851, thirteen years before the Sanitary Fair. Considering its monumental size, the painting was probably rolled for shipment from Germany and framed only after it arrived in New York. Indeed, on October 14, 1851, the *New-York Daily Times* reported that the painting would "positively be exhibited during the latter part of this month. . . . The delay in its exhibition is caused by its having been sent over without a frame."[45] An article in the *Literary World* published four days later remarked, "We saw this painting under *great* disadvantages, it being set against the wall, without a frame, and in a bad position for light, but we are sure that the highly-wrought anticipations of the public will be more than realized."[46]

Washington Crossing the Delaware, with its new frame, was ready for viewing at the Stuyvesant Institute on October 29, 1851. Morillo Noyes, a businessman from Burlington, Vermont, echoed the sentiments of the steady stream of Americans who crowded the gallery. On November 11 he wrote to his wife: "Upon my return down Broadway, it being quite early in the evening, I was induced to pay a visit to Leutze's Painting of 'Washington's Crossing the Delaware,' now about two weeks [on] exhibition in this country. It is certainly a meritorious & magnificent work of art, and forcibly illustrates the skill, beauty & grandeur of man's efforts when perseveringly directed for a worthy & noble end. The size of the painting is enormous, meaning, as I should estimate, 24 or 30 feet in length, by 18 or 12 feet in height. The frame is very rich & elegant, upon which among other striking selections of important Revolutionary events,

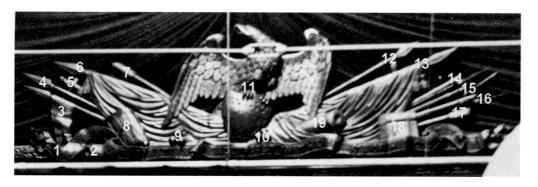

33. Detail of one of the 1864 photographs (fig. 32), with each object in the crest numbered to facilitate research

are – 'First in War, First in peace & First in the hearts of his Countrymen.' It would certainly gratify you much to see it, & much do I wish that you could do so. Its success so far has been highly favorable."[47]

The report from the Museum also explored historical precedents for depictions of Washington with martial emblems. Each individual object in the crest was numbered on a detail of the Brady photograph (fig. 33), and examples were gathered of related styles of decoration in use at the time: eagles, military heraldry, rifles with fixed bayonets, cannons and flags, and the unfurled ribbon bearing text that sweeps across the bottom of the crest. Several words and letters on the ribbon were visible in the photograph: the word "WAR" draping over the cannon, the letter "F" just right of center on the drum, "IN" centered under the left set of cannonballs, "PEACE" after the fold and left of the shield, and "FIRST" centered under the right set of cannonballs. Clearly the ribbon contained the phrase "first in war, first in peace, first in the hearts of his countrymen" that Henry "Light Horse Harry" Lee used in 1799 when he eulogized Washington in Congress. By the 1850s Lee's words were embedded in popular culture.

Armed with the findings of the Museum's report, we made a trip to the New-York Historical Society with our studio manager, Myron Moore; our master carver, Felix Teran; and our expert woodworker, Ernest Pollman. There we were able to view firsthand many items from the period that were depicted in the crest: rifles, bayonets, muskets, cannon rammers, cannonballs, drums, pikes, and carved spread-winged eagles. Examining these objects allowed Teran to articulate details in his carving that were indecipherable in the photographs.

After our thorough visual and historical review we began planning for construction. The Brady photographs were scanned at the highest possible resolution to allow for enlargements. Because the original photograph was taken at a slight angle, our scan was skewed to square it and to match the known proportions of the painting. Once this was complete, we were able to determine the exact dimensions of the crest, the width of the molding (13 inches), and the spacing of elements within the profile. The classic cove profile and the essential ornaments visible in the photographs, including the acanthus-leaf motif near the sight edge and the leaf-and-berry pattern that runs along the top rail (fig. 34), are typical of American frames of the 1850s, so we searched our extensive inventory for frames of the same period as the original Leutze frame. Although we found examples that were identical in style (see fig. 35), the scale was far too small, and the decoration on the prototypes had to be enlarged to the correct proportion for the Leutze frame. Once we had determined the correct size and spacing of the ornaments, we were able to make a detailed drawing of the proposed profile of the new frame.

With the profile drawing in hand we calculated how much material would be needed to build the frame. The profile was 9 inches high and 13 wide and the two horizontals more than

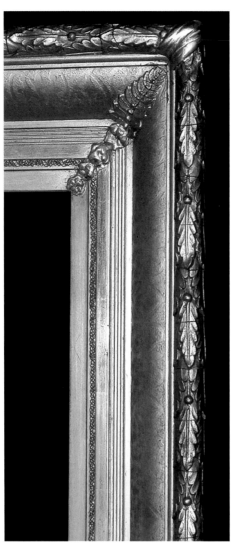

34–35. Blowup of the leaf-and-berry pattern along the top rail of the frame in the 1864 photographs and a detail of an 1850s frame with nearly identical leaf-and-berry ornament

24 feet long. For dimensional stability and ease of shaping the molding, and because of the limitations of the available materials, the frame had to be crafted from nine separate sections of wood laminated together. Shaping the profile would reduce the weight of the wood to some degree, but when we factored in the addition of the gesso layer and the metal connecting and hanging hardware we still predicted that the frame would weigh approximately 2,000 pounds. (The weight of the finished frame with the crest is about 1,400 pounds.) To determine the quantity of gold leaf we would need to gild the frame we estimated the smooth surface area (including the crest and corner shields) at 250 square feet. Because a carved or cast surface, particularly one with high relief, requires additional gold leaf, we doubled the area. Even so, our initial estimate—7,500 leaves of gold—was low; the finished frame used 12,500 leaves.

Creating the monumental frame required more than three years of close collaboration between our staff and the staff of the Metropolitan's American Wing. We wanted to be certain that each detail of the frame was carefully scrutinized for accuracy and authenticity. In order to accommodate the evolving frame alongside our other regular projects we developed a special approach to storing it as it was constructed. The only space in our studio that was large enough was near the ceiling, so we designed three platforms, two 3 by 8 feet and one 3 by 16, that could be raised and lowered and that would be strong enough to support the considerable weight. We carefully considered the structural specifications of all the materials before building the platforms, each of which was supported by two two-ton chain hoists as well as two redundant safety straps.

Consulting the enlargements of details from the historical Brady photographs and photographs of period objects from the New-York Historical Society, we began to make models of the crest and its details. These small models helped us resolve spatial relationships such as how much the eagle should tilt forward to be seen correctly from below and the depth of the relief in the crest. We first carved an 18-inch-wide model of the entire crest (fig. 36). Next we created a 22-inch-high model of the eagle alone in the proportions and style typical of carving from the mid-nineteenth century (fig. 37). We partially gilded the model, basing the color and patina of the gilding on a remarkably well preserved American frame of the 1850s in our collection. The Museum curators reviewed all of our models and offered suggestions for making the frame as historically accurate as possible. Judging by the sheer size and weight of the original frame, *Washington Crossing the Delaware* was clearly intended to have a permanent home as a monument to a nation's most honored hero. As we crafted our replica we began to feel toward it

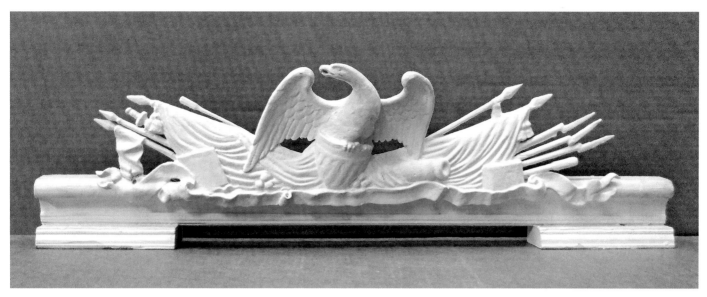

36. Small maquette of the crest for the new frame. The model was 18 inches wide.

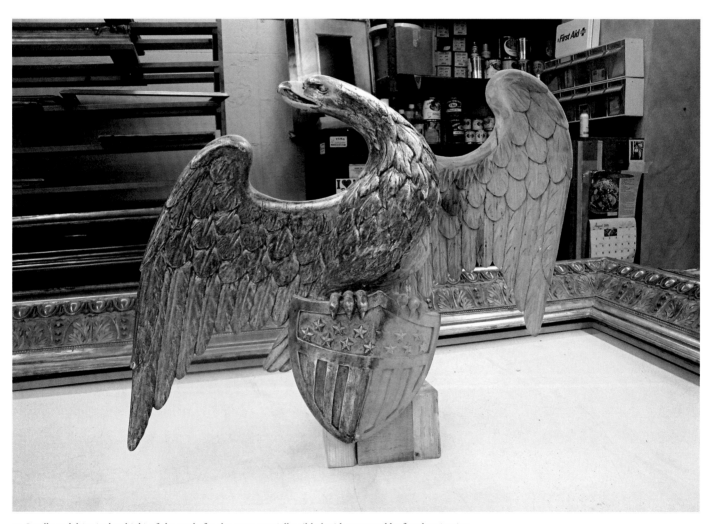

37. Small model (22 inches high) of the eagle for the crest, partially gilded with proposed leaf and patination

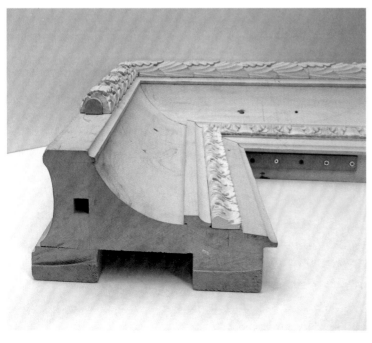

the same awe and reverence that must have greeted the painting's first unveiling.

The two-dimensional calculations we had made gave us a good idea of how the frame would appear when viewed from the front, but we needed to account for its depth as well. Again, we began with a drawing, using a profile from a similar frame in our collection as a model and adjusting it to a width of 13 inches to accommodate the actual depth of the Leutze painting on its stretcher. Once we were satisfied with our finished profile we shaped enough wood to make a full-size 4 x 4 foot corner of the molding (figs. 38–40), not only to verify that our profile was accurate but also to work out the complexities of how the frame would be joined. To make the corner a true sample, we also made full-scale carvings of the acanthus-leaf motif near the sight edge and the leaf-and-berry ornament on the top rail, both of which are variations of popular embellishments on American frames of the mid-nineteenth century.

Because the margin of error when translating an image measuring less than an inch to a finished product more than a foot wide is so great, throughout the construction process we referred continually to Brady's photographs of the original frame. When we did this with our corner sample, we could see that the cove section (the recessed area) was too narrow and too shallow by a quarter inch. As it was, the star and tendril ornaments on the cove would be cramped, and the overall proportions seemed to lack grace. We made the necessary adjustments and compared the corner again to the photographs. Satisfied that all was now well, we were ready to begin the construction of the final molding.

The curators overseeing the project approved the sample molding, but after discussions with them we chose an alternate method for fabricating the two primary ornaments. We had offered to carve all of the ornaments in wood, which would not have been excessive for such an important frame. On nearly all American frames of the nineteenth century, however, the decorative ornaments were molded of composition, or "compo" as it is usually called, and then applied to the wood frame. Compo is a

38–40. Final profile drawing of the new frame and the full-size sample (4 x 4 feet) of the corner of the molding

combination of chalk, hide glue, and linseed oil formed into a pliable putty. The compo is pressed into intricately reverse-carved wood molds and then transferred to the frame. (Today we sometimes use different materials, such as silicone, to make casts of the desired ornaments.) Once dry, the compo becomes hard and can be treated just as if it is carved wood. Hand carving inevitably produces variations throughout the work, however carefully a carver attempts to be faithful to a specific design. In contrast, casts are absolutely faithful to their mold. If the entire frame was carved it would take longer to finish the project, because for a unified effect the work would have to be done by a single carver. If the ornaments were cast more people could be employed and we could finish the project faster, though the total number of staff hours would be about the same.

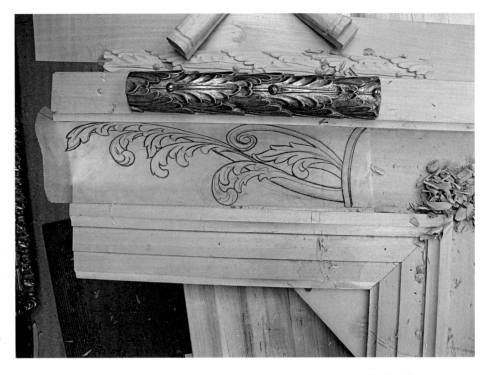

41. Section of leaf-and-berry ornament scaled up to the appropriate size. This one-foot section was used to create five-foot-long molds.

Ultimately the curators decided that the ornaments would be cast and the crest and corner shields hand carved. With this signal to go ahead we began creating molds for the final castings. The ornaments carved in wood for the sample corner had been only a foot long, and we needed five-foot molds for the frame. Silicone molds were made of our one-foot carved wood sections, and then each was cast five times (see fig. 41). The five sections were then joined together, and the seams where the pieces met were carefully sanded and recarved for fluency. New molds were then made of these extended sections.

The cast of the leaf and berry at the top of the frame required special treatment due to its size. It is roughly a cylinder 2½ inches in diameter, and we knew from experience that casts this thick dry slowly and are likely to crack from internal stresses created by the curing process. By embedding a wooden dowel with a diameter of 1¾ inches in each segment of casting, we forced the casting material to a thickness that would dry more quickly and evenly and with less internal tension. The wooden core had an additional benefit: it provided a solid material through which we could secure the ornament to the frame with screws. The thick cast ornaments on nineteenth-century frames were often constructed this way.

Throughout the process we had been giving much thought to the best way to join the frame. A frame of such monumental size and weight would have to be transported in sections and assembled on site, without glue at the corner miters or in the attachment of the crest. Fortunately, the profile of the frame created very stable cross members that structurally resemble I beams. The decorative shields at the corners, which span the miters and are bolted to the adjoining sides, serve as gussets (fig. 42). Very large frames are often assembled with lag bolts, but repeated assembly and disassembly can strip the bolts' wood-screw threads and render them ineffective. Our solution was to use machine bolts that meet metal inserts securely embedded in each of the adjoining sides. At each corner two machine bolts (hidden by wooden plugs)

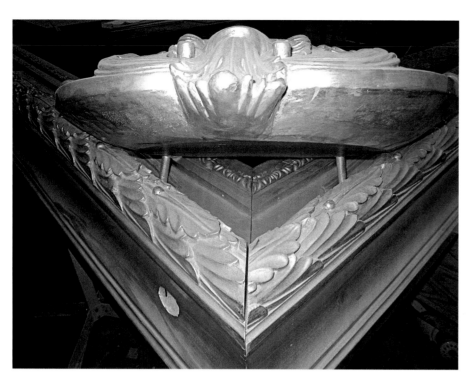

42. Each of the four shields was through-bolted to the frame.

go through the side of the frame, and two more bolts thread first through a 16-inch metal corner bracket on the back of the frame, then through the frame itself, and finally into the corner shields. This construction method is called through-bolting. As another precaution, a second metal bracket set perpendicular to the first was mortised into the rabbet, or rebate, the recessed area beneath the sight edge in which the painting rests.

As our woodworkers were constructing the frame our master carver was creating the crest utilizing a full-scale blowup of the Brady photograph. The computerized enlargement was divided into sections small enough to print and the printed sections reassembled. From the resulting lifesize photograph of the crest a drawing with accurate proportions was made. The drawing was then reworked to clarify details and to determine the exact position of the letters on the ribbon across the bottom. Measurements were then transferred directly from the drawing on to large blocks of wood shaped to approximate the primary structure of the crest and its decorative elements so that each could be fully realized with precise carving (see fig. 43).

The unfurled ribbon across the bottom of the crest presented its own challenge. Carving wood to simulate fabric that appears to flow and fold with natural ease is extremely difficult. To aid the carver, pieces of stiff cloth were cut to the full size of the ribbon and dipped in plaster. The cloth was then carefully draped and suspended to imitate the folds visible in the 1864 photograph. Once dry, this became a valuable three-dimensional reference that served as the basis for a carved sample of the banner. We could not decipher the typeface that had been used for the text on the banner; after exploring several options we settled on a font called Bookman Old Style, in bold and all in capital letters (fig. 44). The eagle was carved separately and then affixed to the rest of the crest (figs. 45–48). Even though Felix Teran had already created the 22-inch model, seeing the majestic eagle emerge fully formed from static blocks of wood was breathtaking. The way the talons grip the shield, the sweep of the wings showing every delicate feather, and even the tongue in the bird's open beak are truly awe-inspiring.

Once the crest was complete we affixed special metal brackets to its back that extend down to fit into reciprocal spaces at the back of the top center section of the frame. When the frame was assembled in the gallery the crest was lowered down into place and secured (see fig. 56).

The four round ornaments at the corners of the frame were a vexing mystery. The photographs were no help: the precise shape of the ornaments and their decorative embellishments looked different from different angles, and though we could make out what looked like text, there seemed to have been a different word on each corner (figs. 49, 50). We finally decided that the round objects were shields of some sort with decorative swirls at the outer edges. We made a lifesize drawing and sent it to the Museum. The curators asked us to make the ornaments less

43. The eagle on the crest was carved separately from a flat block of wood.

44. Detail of the carved crest before it was gilded

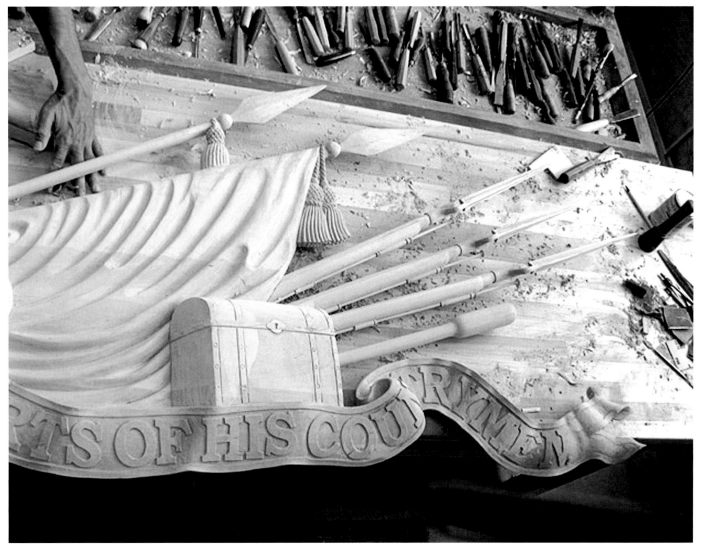

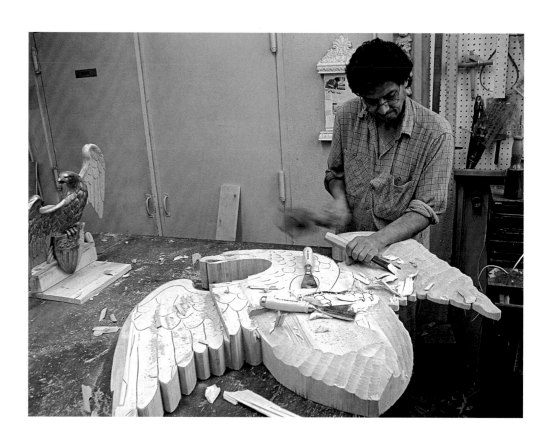

45–47. Master carver Felix Teran
carving the eagle for the crest

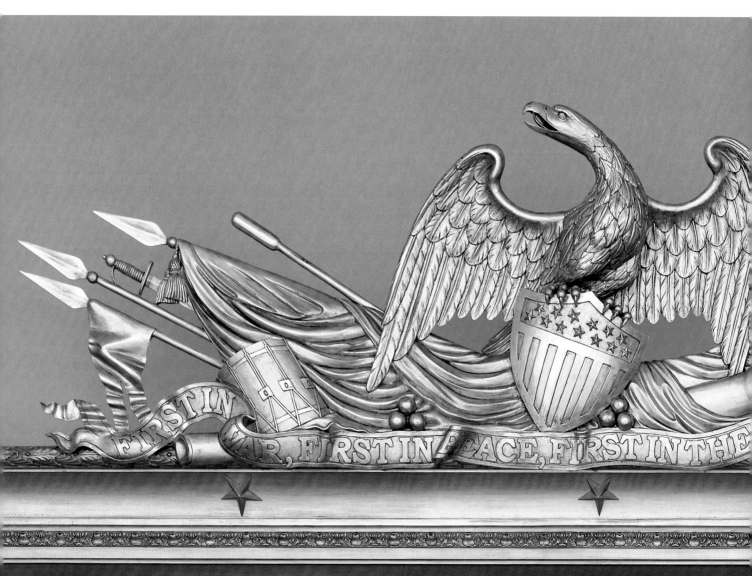

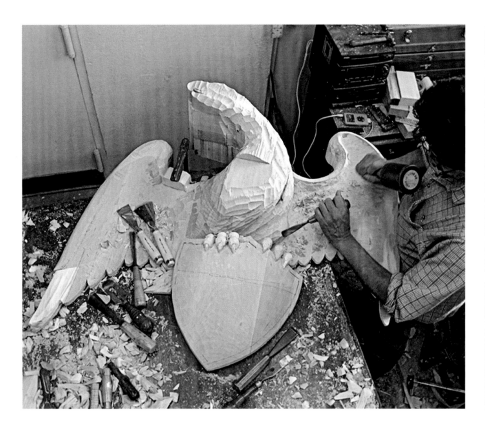

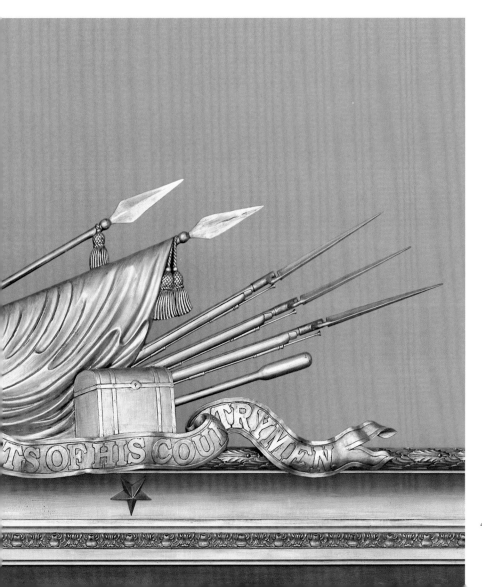

48. The finished crest

49–51. Blowups of two of the corner shields in the 1864 photographs and, at right, one of the corner shields for the new frame prior to gilding

52. Midway through the gilding and burnishing phase

round and more apple-shaped and the carving more florid and Rococo, with articulated veins and frilled edges, providing images of mid-nineteenth-century furniture with similar flourishes. As for the words, after considering "just," "sincere," "humane," "dignified," and other possibilities from Henry Lee's funeral oration, the curators decided to err on the side of restraint. In the end we created four shields with a convex surface and lush, undulant flourishes around the edges (fig. 51). Happily, they look quite beautiful and appropriate without any additional embellishment.

Once all the components of the frame had been molded or carved, they were gilded (fig. 52). To determine the best finish we consulted other period frames in our inventory, but because we decided that as a trophy or a shrine to patriotism the frame would have been bright, we aimed for a much livelier appearance than our initial studies had indicated. Then, too, because of its size the Leutze frame would not have been handled often, and it would have retained a dramatic crispness, darker in the recesses but bright overall. (A smaller frame on a painting of conventional size becomes darker on the high points of its form through handling and age.) The relief of the carving of the crest was emphasized, not only because it is the most sculptural element of the frame but also because installed in the gallery it would be nearly twenty feet off the ground. Seeing the completed crest fully gilded was exhilarating. Fourteen feet across and rich in detail, it perfectly reflects the drama of Washington's crossing.

In the summer of 2010 the frame was at last complete. It was delivered in component parts for later reassembly in the gallery (figs. 53, 54). The two longest (horizontal) sections—too large to fit in an elevator—were carried in through the front doors of the

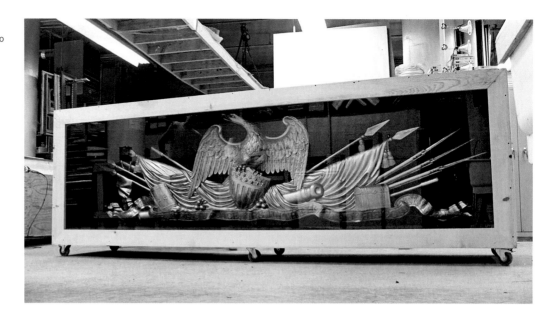

53. The crest in its crate, ready to be transported to the Metropolitan, 2010

Museum and up the Grand Staircase! The finished frame was reassembled and affixed to the canvas and the framed painting hoisted into position in the New American Wing Galleries, where it claims pride of place on the far wall of a grand skylit space (figs. 55, 56).

Of all the frame projects we have worked on, this has clearly been the most important and magnificent. From the genesis of the project, when the frame was just a question and then an idea, throughout the nearly four-year process of bringing the frame into being, every member of our staff brought his or her skill, devotion, and dedication to the task. We are honored and proud to have played a role in restoring Leutze's *Washington Crossing the Delaware* to its original glory.

54. Carrying the two horizontal cross members of the frame up the Grand Staircase at the Metropolitan, 2010

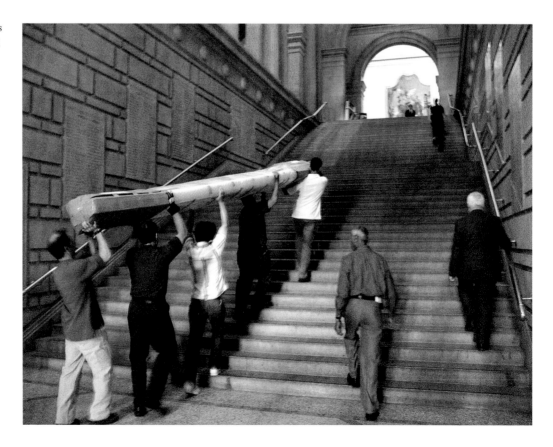